THE ART OF DRAWING

Drawing
The Clothed Figure

PORTRAITS OF PEOPLE IN EVERYDAY LIFE

Giovanni Civardi

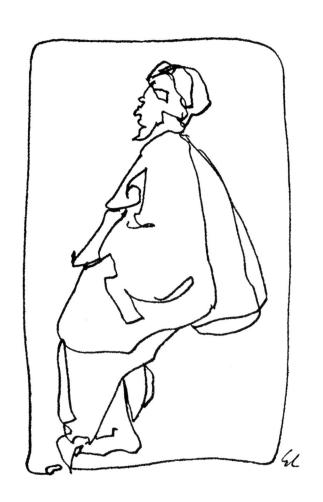

SEARCH PRESS

First published in Great Britain 2005 by Search Press Limited,
Wellwood, North Farm Road, Tunbridge Wells, Kent TN2 3DR

Originally published in Italy by Il Castello Collane Tecniche,
Milano

Copyright © 2003 Il Castello srl
Via Scarlatti 12, 20090 Trezzano sul Naviglio (MI)
Tel. 02 48401629 - Fax 02 4453617 - e-mail: il_castello@tin.it

English translation First Edition Translations

ISBN 1 84448 072 0

Text processing by computer: Elena Turconi
Photolithography: Più Blu srl, Milan

Printed in Malaysia by
Times Offset (M) Sdn Bhd

INTRODUCTION

At art schools, at academies or even on each painter's or sculptor's individual academic journey, drawing the human figure from life has always been considered an essential cornerstone. Even nowadays, when the most varied and antithetical trends in art and expression coexist, the artists who seriously wish to base their own 'freedom' on sound technical training often choose to devote a considerable part of their research to drawing the human body, one of the most important subjects for artists since way back in time.

When we talk about studying the figure, we mainly mean the nude figure, but although this is the universal assumption it is also clear that, except in certain circumstances, there are many more opportunities to witness and study clothed or partly clothed figures than nude ones. And the field of artistic expression is even wider in this respect: just think about portraits, photography, comic strips, illustrations, and so on. In all these areas it is obvious to note that clothes cover – and are influenced by – anatomical shapes and movement.

I thought it appropriate therefore to suggest with this book a rather difficult, but very interesting, theme: that is, drawing what used to be sometimes classified as 'genre' scenes. Characters caught in various situations in everyday life, in our surroundings, in places we usually frequent or that we happen to visit…, subjects found in the home, in the street, on means of transport or in public places.

Drawing is the most immediate art form, the one that most easily enables us to portray quickly what we see. In order to draw well, we especially need to know how to observe carefully, interpret according to our style and our sensitivity, and combine facts with fantasy. Indeed, a drawing from life, done quickly, or a simple sketch, does not require much processing of details but, rather, the ability to know how to pick out the essential elements that seem the most meaningful for portraying the subject. When drawing figures, whether nude or clothed, it is then necessary to consider them as a combination of simple shapes (but strictly correlated in the overall shape), to assess their proportions, balance, the 'type' of attitude, and so on.

In this book I have tried to suggest at least some subject matters for reflection and practice which, I hope, will inspire you and be of help in honing your observation skills, by applying them to a topic that is sometimes complex but, precisely because of this, always rewarding and useful.

TOOLS AND TECHNIQUES

To draw rapid portraits of characters or make sketches of figures, especially if you are working from life, you can use the simplest and most well-known tools: pencils, charcoal, pastels, pen and ink, watercolours, felt pens, etc.

Each of these produces different effects not only because of the specific nature of the material and technique, but also because of the characteristics of the medium on which it is used: smooth or rough paper, card, white or coloured paper, etc. The drawings shown on this page and the next have been produced using some tools that are commonly used, but suitable for depicting, efficiently and with good effect, the scenes that we happen to find in the street, in public places, on our travels or in various surroundings frequented socially.

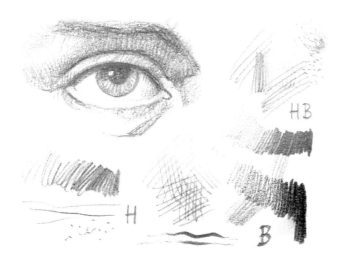

Pencil and graphite leads (H, HB, B) on rough paper

Pencils are the most commonly used tool for any type of drawing and, for the clothed figure and portrait, they can be used expressively and creatively, and are convenient implements. They can be used for very elaborate drawings or for short studies and brief reference sketches; for the latter, micro leads are suitable, whereas for the former you can choose graphite leads with a larger diameter and softer gradation. Graphite leads which can be used by inserting them in push-button holders, like pencils (graphite leads inserted in the wood casing), are graduated according to consistency: from 9H, very hard, which draws fine, faint lines, to 6B, very soft, which easily draws thick, dark lines.

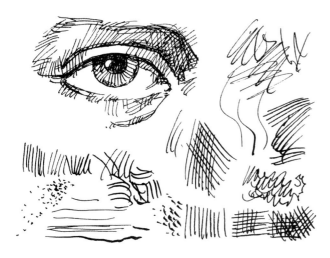

Pen, nib and black China ink on semi-rough paper

Artists frequently use ink. It can be applied either with the brush or the nib, but special effects can be obtained by using, for example, bamboo cane, nibs with a thick point, fountain pens, 'technical' (Rapidograph) pens, felt pens and ballpoint pens. The tonal intensities are usually graduated by criss-crossing the nib strokes more or less densely and, therefore, it is advisable to draw on paper or card that is rather smooth and of good quality, to prevent the surface from fraying and the ink from being irregularly absorbed.

Compressed charcoal on paper

Charcoal is perhaps the ideal means for sketching figures from life because it is very easy to control when shading and can also help achieve very clear details. It must, however, be used quickly, concentrating on conveying the overall tonal and volumetric masses. In this way it can express its best qualities as a versatile and suggestive tool. You can use compressed charcoal or wood charcoal, paying attention in both cases not to dirty the sheet. The charcoal strokes merge and blend together when rubbed lightly, for example, with a finger and the shading can be toned down by applying a soft rubber. The finished drawing must be protected by spraying it with a fixative.

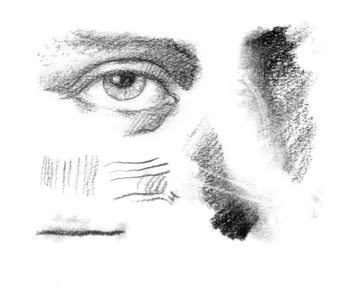

Monochrome watercolours (washes) on semi-rough paper

Watercolours, water-soluble inks and China ink diluted with water are very suitable for studying figures and drapery, although they are more like painting than drawing, given that they are applied with a brush and require synthetic and expressive tonal vision. For quick studies from life you can use graphite leads or water-soluble coloured pencils, whose strokes are easily merged by going over them with a brush dipped in water. In this case, it is preferable to use thick cards or cardboards so that the moisture does not make the surface wavy and irregular.

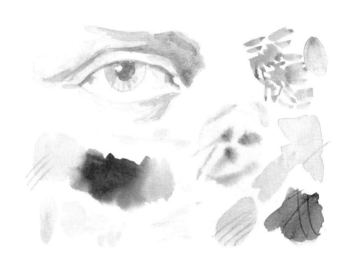

Pencils, inks, white tempera on rough paper

Techniques are 'mixed' when different tools are used to produce a drawing and look for unusual effects. They are always graphic means of expression, but their use requires careful control and a good knowledge of the tools, so as to avoid confused outcomes with poor aesthetic meaning. Mixed techniques are very effective if used on mediums that are rough, coloured or at least of dark tonality.

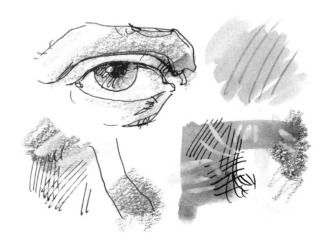

PRACTICAL CONSIDERATIONS

WHERE TO FIND 'MODELS'

First find, then seek

JEAN COCTEAU

When studying clothed figures subjects can be found anywhere, of course a lot more often than you find semi-clothed or even nude figures, which you find only in appropriate circumstances and places.

All it takes is to look around a bit, carefully and inquisitively, to discover an almost unlimited series of suitable opportunities to practise drawing the human figure in everyday poses and actions: in the streets, in public places (gardens, parks, stations, restaurants and bars, offices, theatres, exhibitions, public transport) and, above all, in the actual environment in which we live (our relatives, friends, work or academic colleagues, etc.).

The opportunities, in short, are so frequent and common that we are almost spoilt for choice.

WHAT TYPE OF DRAWING TO DO

We need to distinguish schematically between two broad areas of 'research':

a) The rapid, immediate, sketch from life, which is almost a quick graphic note focused on the attitude, the 'character', the gesture, etc. of the subject we are observing (see page 43). It is a drawing produced with few lines and in a short space of time (taking not more than a few minutes), catching the precariousness or the fleetingness of the attitude that attracted us. It also usually presupposes small dimensions (those of a pocket-size notebook or sketchpad), a simple, agile tool (pencil or ballpoint pen) and a lot of discretion, because the model must be captured almost without his or her knowledge (many subjects, luckily for us, pretend not to notice…). The drawing should be made from a certain distance, or else we lose the naturalness and spontaneity of the attitude.

b) The study from life, which is the one distinguishing many of the drawings proposed in this book and which is technically a bit more elaborate (although it still retains the appearance of a rather rapidly produced and synthetic drawing, without superfluous details). It takes slightly longer to draw (about ten minutes), has larger dimensions and, above all, is made with the agreement of the people depicted. Unless you take snapshots which, you could say are 'stolen', it is actually a matter of producing a sort of 'portrait' and, therefore, the model is well aware of what we are doing. It is obviously appropriate to ask the model's permission to be drawn, but it is also necessary (unlike the portrait in the common sense) to maintain the spontaneity of the attitude that attracted our attention.

In these circumstances it can be useful to take some photos as well, so that we have some reference documents in case, later on, we happen to want to complete or add to the study from life in a more elaborate painting. Whatever the circumstances, it is appropriate to explain things clearly to our chance models and obtain their permission, assuring them that our drawing is for academic and not commercial use only.

Photographs, moreover, are almost irreplaceable when portraying very small or lively little children and for catching moving attitudes and interesting but complex scenes.

EQUIPMENT AND TOOLS OF THE TRADE

Even if you wish at some point to produce a slightly more elaborate study of the simple sketch it is advisable to have with you suitable tools and equipment for a job that can nevertheless be done quickly: pencils of various gradations, felt pens, coloured pencils, charcoal, some watercolours, etc. (see page 4); a medium-sized sketchbook about 40 x 50cm (16 x 20in); a small bag with some emergency equipment (a paper cutter, some rags or paper serviettes, a kneaded rubber, a container for water, etc.); and a camera, to obtain the reference material or documents that cannot be 'captured' any other way – an instant camera (Polaroid) is very good, but so is a digital one because it usually allows one to check, on a small scale at least, the effect of the composition and the effectiveness of the viewpoint.

For nearly all the drawings produced for this book I used graphite leads of various gradations, and some brown watercolour tempera brush strokes; it is a simple technique that I find suitable for nimbly adding some rapid tonal notes.

LEARNING TO OBSERVE AND SIMPLIFY

It is important in this type of drawing to learn to simplify, that is, reduce to the most essential and meaningful the many elements that describe the human figure, particularly if clothed. Consequently, it is advisable to focus our attention on the attitude and overall shapes, on the position assumed (which must appear fairly spontaneous, casual, as if taken by surprise, in an instant, and not 'studied'). It would mean avoiding as far as possible giving the impression that it is a conventional, posed 'portrait', unless this is what you really want (see, for example the drawings on pages 21, 24, 25 and 30).

It would also be good to make the figure stand out from the surrounding elements, closely examine the figure's clothes, their style, the creases they form, consider how to arrange the various segments of the body in the space, how they fit together in the composition and the lightest and darkest tones, the play of the most intense areas of light and shade, etc.

FIGURE AND BACKGROUND

Nonetheless, making the figure stand out should not overlook the fact that there is still a background surrounding it. 'Isolating' the figure is allowed and often to good effect, but in many cases it is appropriate to consider, for example, that next to a person there can be other people and that therefore our interest can be drawn not by a single figure, but by the way in which the group is arranged. Or, it would be useful for us to add, next to the figure, some elements of the background or some objects relating to the action taking place (see page 52). This integration is useful for the purpose of further clarifying the representation and making the figure less isolated or uprooted from the scene of 'life' that is happening and that attracted our attention, arousing our artistic sensitivity and our desire to draw it.

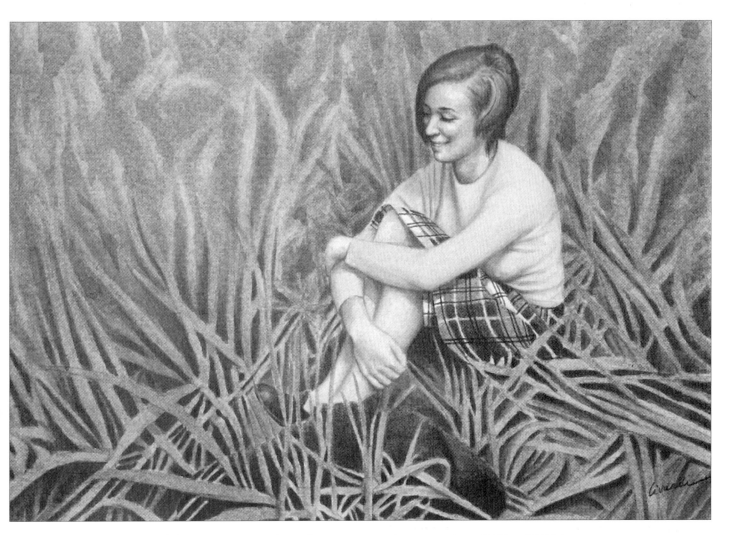

Illustration for a 1992 "Confidences" story, acrylic colours on masonite, 35 x 50cm (13¾ x 19¾in)

PROPORTIONS AND ANATOMY

Knowledge (brief, but not approximate) of human anatomy is useful to artists because it enables them to depict the body, both nude and clothed, correctly and effectively, with regard to the aesthetic and stylistic purposes they are hoping to achieve. The observation of the live model can be completed by studying the most superficial anatomical structure of the human body, which is important for describing the outer shapes and is represented by the muscle mass supported by the skeleton with its joints and skin covering.

The proportions can be understood as the harmonic relationships between the various parts of the human body; from these relationships it is possible to deduce a set of rules, a standard, that can help the artist portray human beings, based on natural details or adapting these details to the requirements of an aesthetic ideal.

In this sketch I have summarised the main morphological differences between the male body and the female body, considered at adult age. This mainly concerns the skeletal structure, the muscle mass, the location of the subcutaneous fat tissue, the body hair, etc. Comparing the two skeletal structures we see, for example, the usually shorter stature of the woman compared with the man and the wider female pelvis. Other differences are well known and noticeable in a woman compared with a man: the development of breasts, the larger buttocks, the greater inclination of the axis of the arm and that of the thigh, etc.

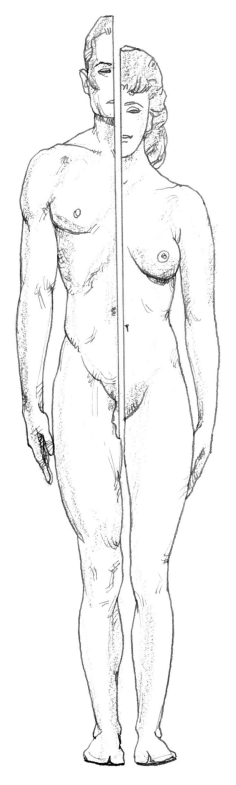
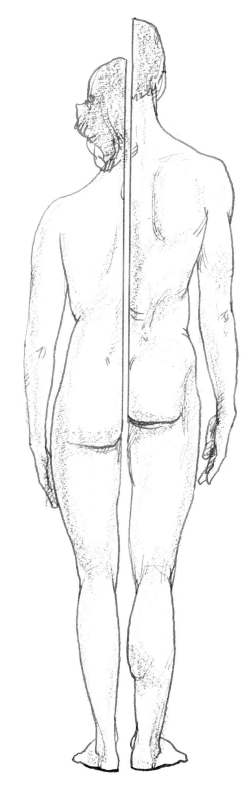

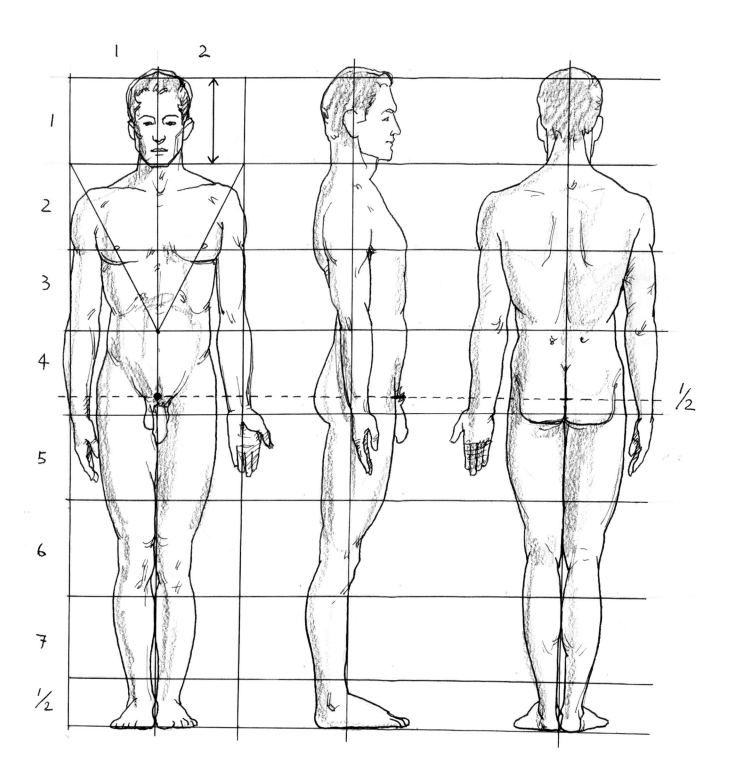

A useful criterion for the naturalistic portrayal of the human figure is the 'scientific' one, illustrated here with reference to the male body. The unit of measurement chosen is the height of the head: the height of the body corresponds to about seven and a half times the unit of measurement; the maximum width, at the shoulders, is equal to two units of measurement, etc. The halfway point of the body height is situated roughly level with man's pubic symphysis, a bit above for a woman. The grid superimposed on the frontal projection of the figure shows clearly enough the relationship between the proportional levels and the relative references on the body.

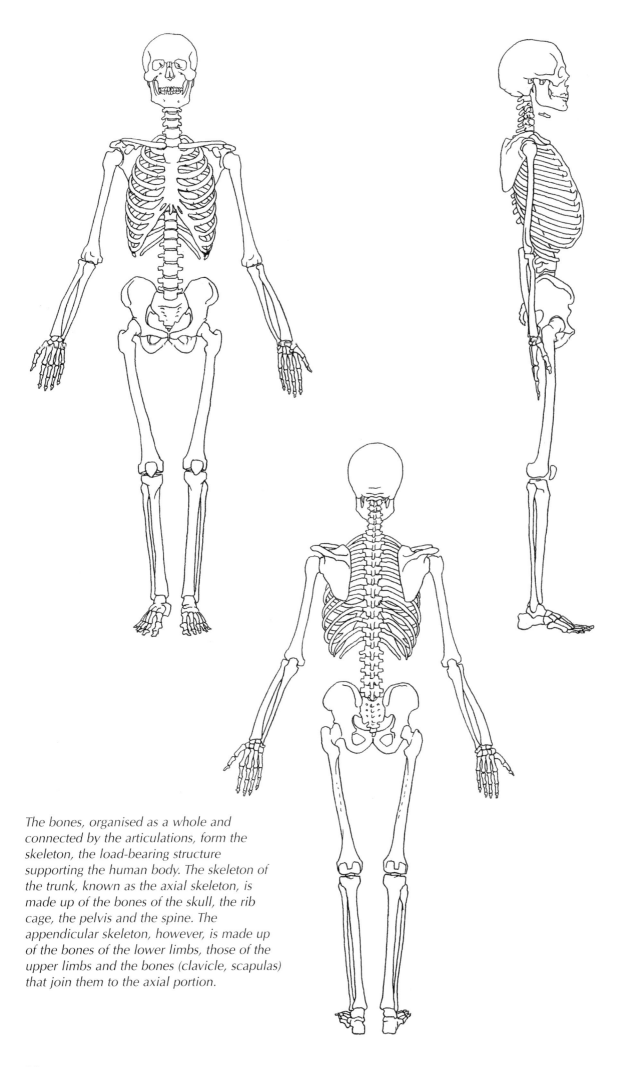

The bones, organised as a whole and connected by the articulations, form the skeleton, the load-bearing structure supporting the human body. The skeleton of the trunk, known as the axial skeleton, is made up of the bones of the skull, the rib cage, the pelvis and the spine. The appendicular skeleton, however, is made up of the bones of the lower limbs, those of the upper limbs and the bones (clavicle, scapulas) that join them to the axial portion.

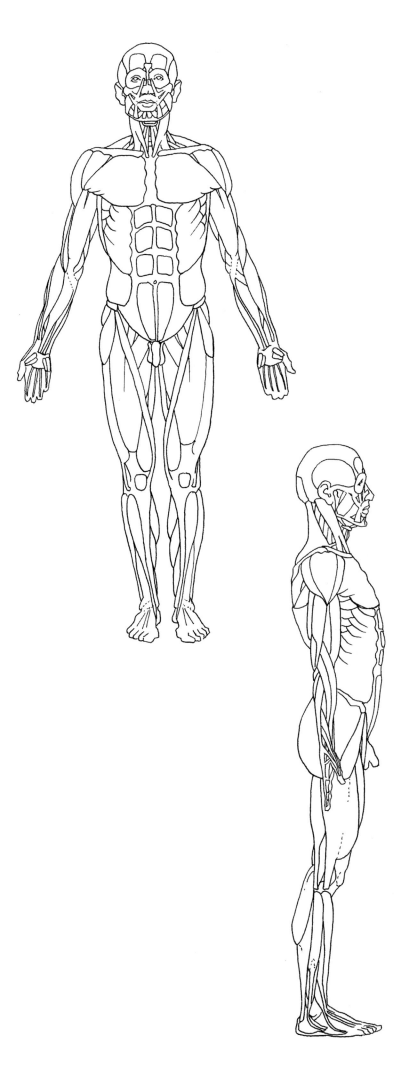
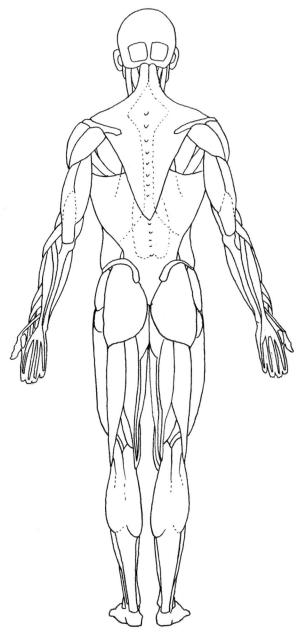

The skeletal muscles contribute to a large extent to defining the outer shapes of the body and, given that they shorten and grow bigger when contracted, they also vary depending on the action carried out and the intensity with which it is performed. The muscles of greater immediate interest to the artist are situated in the superficial layer, below the skin. With the help of an anatomical atlas it will be easy for you to identify and learn some of the characteristics of the many muscles depicted in the brief sketch I have reproduced here.*

NUDE AND CLOTHED: DRAPERY

Studying drapery enables us to analyse and portray in the most effective way the creases that form in different types of material and to observe how they are arranged on the human body. It is easy to see that clothes adapt to the body, still allowing us to sense the anatomy of the body as the drapery covers the points of tension (usually, the articular regions) and creases in the areas of flexion.

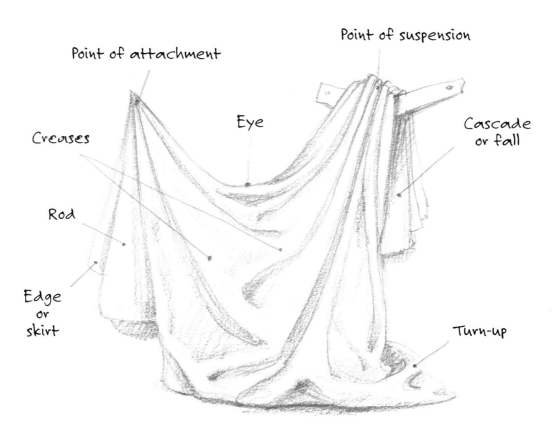

In the schematic drawing shown above I have shown the position that a piece of cloth, hanging from two points, can assume. Depending on the density of the fabric and its textural characteristics, these creases may be more or less evident, simplified or plentiful.

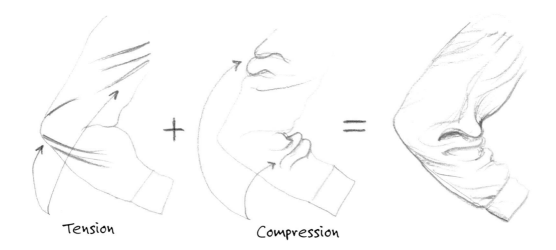

A shirt sleeve provides a clear example of how the creases that form when bending the arm are the result of combining tension lines (which usually radiate from the side when extending an articular joint) with the fabric's curling or thickening created in the areas towards which the limb is flexing.

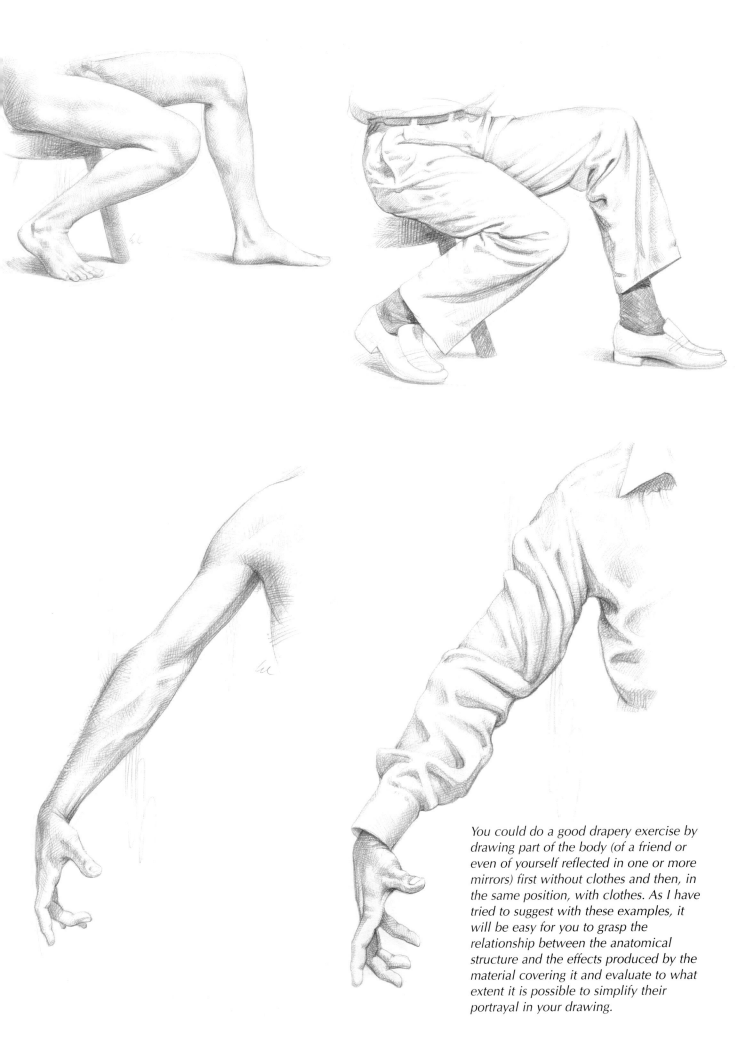

You could do a good drapery exercise by drawing part of the body (of a friend or even of yourself reflected in one or more mirrors) first without clothes and then, in the same position, with clothes. As I have tried to suggest with these examples, it will be easy for you to grasp the relationship between the anatomical structure and the effects produced by the material covering it and evaluate to what extent it is possible to simplify their portrayal in your drawing.

THE HEAD, HANDS AND FEET

Sketches of figures from life often include a sort of portrait even when, due to pressures of time or by choice, the actual likeness is not sought. Nevertheless, one must correctly portray parts of the body that, usually, our clothing leaves uncovered: above all, the head and the hands. However, these parts can sometimes be covered by garments or accessories, such as hats or gloves. Shoes, moreover, are almost always worn. It is therefore important, in these cases and similarly in the one I suggested for the drapery, to examine properly the relationship between the anatomical structure and the clothes covering it, perhaps in the way shown by the drawings on page 15.

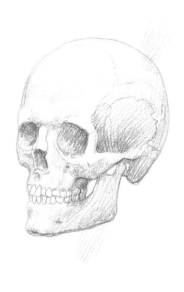
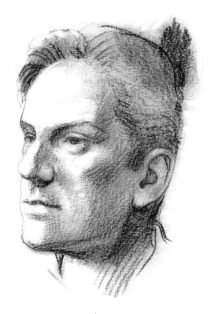

The outer shape of the head is largely determined by the form of the skull, especially in areas where the 'soft' tissues covering it are of very reduced thickness. For example: the forehead, the bridge of the nose, the cheekbones, the chin and the jaw line. We can feel the different consistencies just by touching these parts of our face with our fingers and comparing them with the parts just around them.

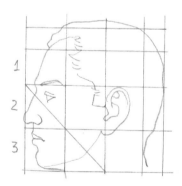
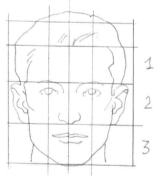

The human head has very precise proportions, and it is the slightest deviations in the relationship between its parts that cause the differences in each individual's facial features. From the sketch reproduced here is easy to deduce, for example, that the height of the face can be divided into three horizontal bands of equal size and that the distance between the pupils is a bit wider than the width of the lips, and so on.

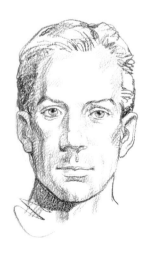
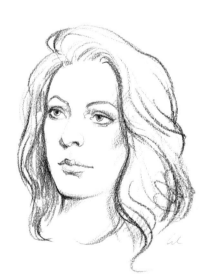

The shape of the male head and that of the female head are slightly different. For example: the male head has slightly larger dimensions; the structure of the male face is heftier and more angular than the female one, which is rounder, more oval.

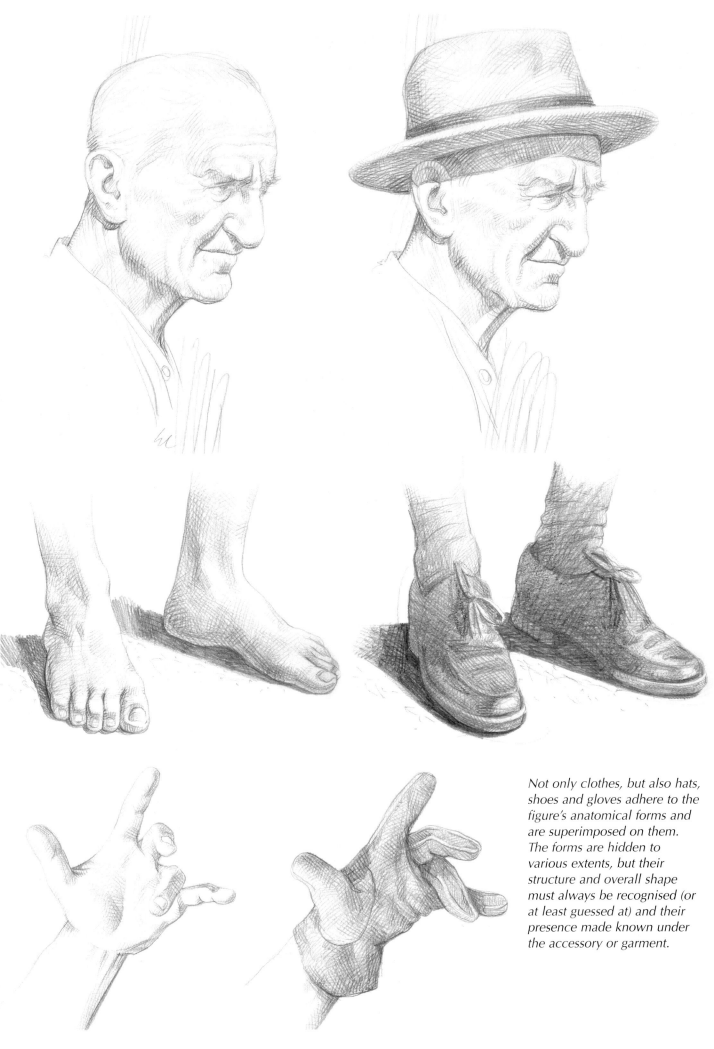

Not only clothes, but also hats, shoes and gloves adhere to the figure's anatomical forms and are superimposed on them. The forms are hidden to various extents, but their structure and overall shape must always be recognised (or at least guessed at) and their presence made known under the accessory or garment.

EXAMPLE OF PROCEDURE

In this chapter I thought it appropriate to show the sequence of the most important stages of a simple procedure (there are others, of course), for drawing a model. It may be a bit academic, but it is useful for sharpening our observation skills with a natural model, and for training the hand to draw rapid and effective sketches of figures from life. The stages have been picked out and reconstructed, for demonstration purposes, but it is obvious that they progressively come together, one to the other, until they achieve the desired effect or the study whereby we consider our drawing finished, which, in this example, is shown on page 21.

Stage 1

Dimensions and 'space': by observing the model you can pick out the relationship between the maximum height and the maximum width of the subject (also considering the shape and size of the sheet you are drawing on) and lightly draw, approximately but carefully, the area encompassing the contours and main mass of the figure.

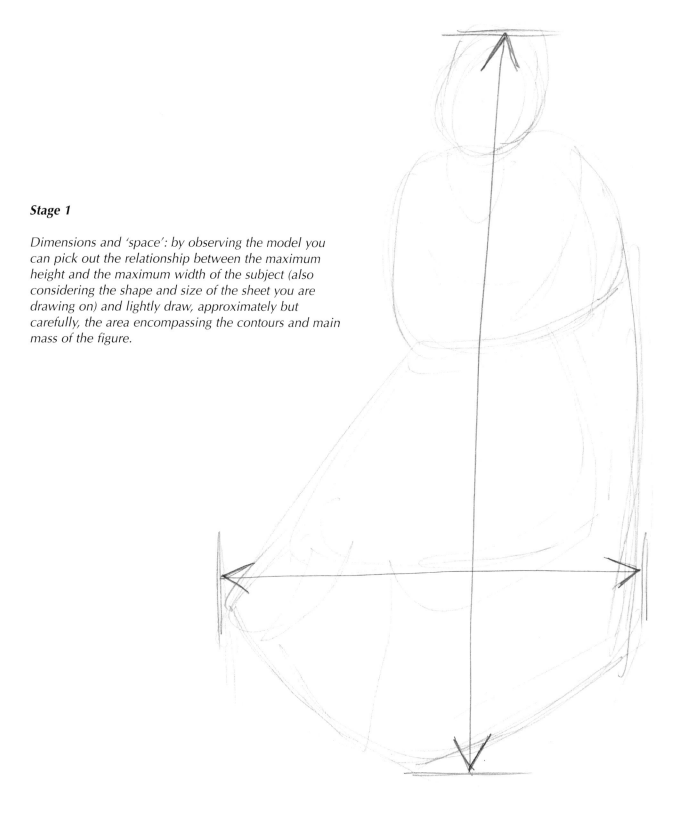

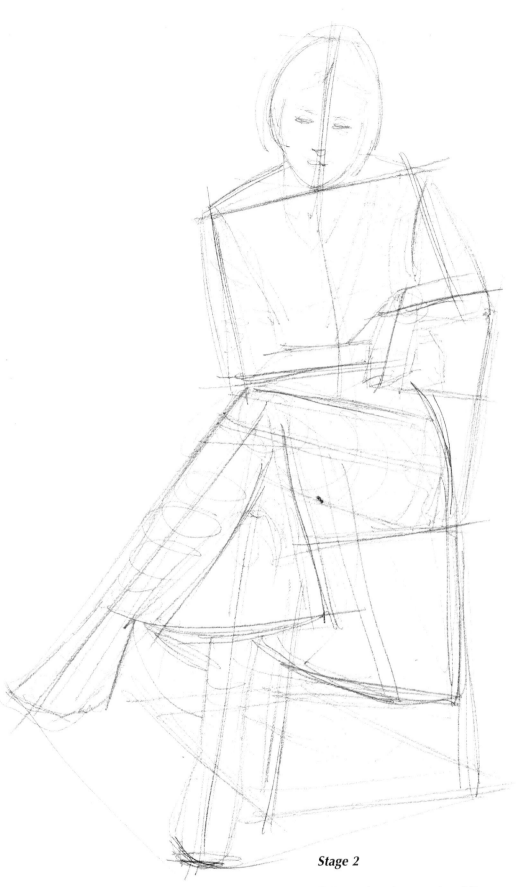

Stage 2

Structural and proportional lines: continue to define further the most relevant shapes of the figure by drawing, for example, the main axes of the limbs, the angles by which the various body segments are connected, and the inclination of the axis between the shoulders. At this stage it is preferable to draw, very lightly, the 'decisive', schematic lines that show the geometric structure, in order to capture the overall attitude of the figure and suggest the anatomical shape below the clothes, as if the clothes were transparent.

Stage 3

Outlining: make the schematic lines begun in the previous stage smoother, more natural and spontaneous, and further define the essential contours of the various parts that make up the figure: the head, the arms, the shod feet, the clothing, the chair, etc. For example, mark the main creases in the skirt and blouse and also suggest the approximate outline of the areas where the shadow appears more intense.

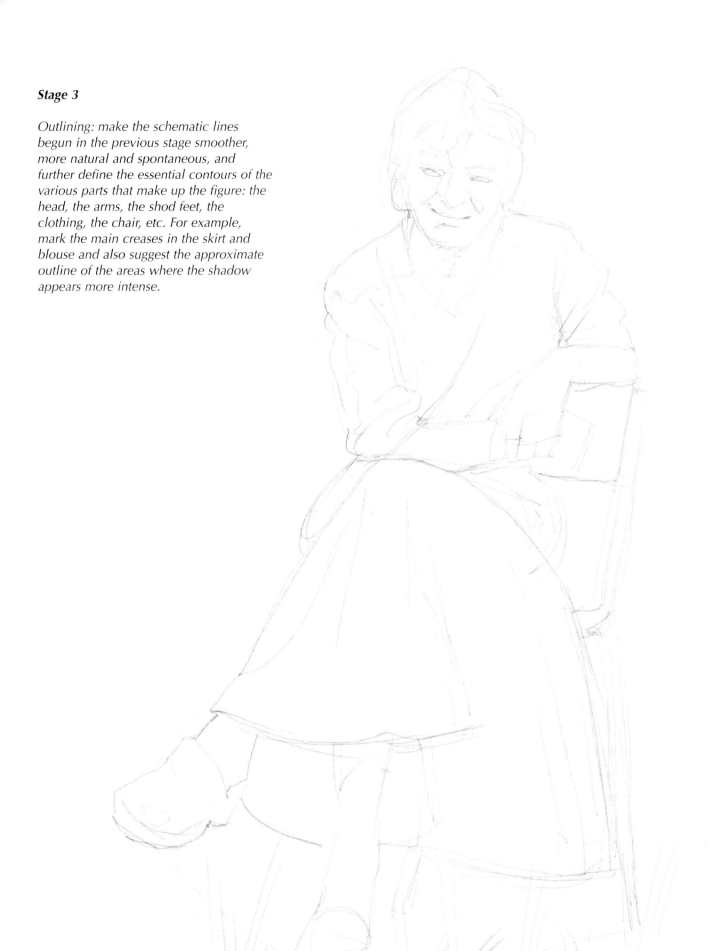

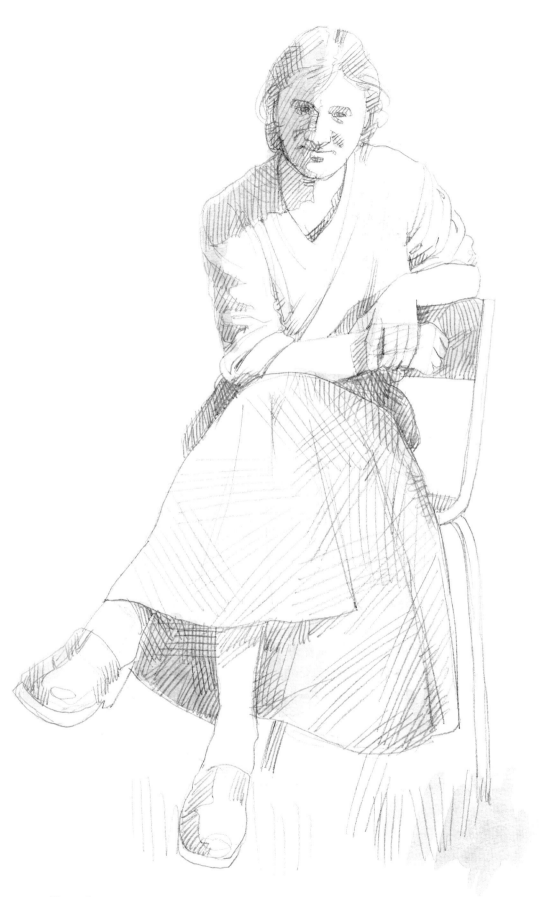

Stage 4

Marking the main shadows: draw the outlines of the various parts more carefully and suggest the 'volumetric' characteristics of the drawing, adding the more extensive and darker areas of shadow and, for now, only some intermediate tones. In this case, apart from a quick, loose, pencil sketch, I have added some brush strokes of very diluted brown tempera.

Stage 5

Drawing shadows and modelling the figure: gradually the drawing is approaching the final version (although maintaining the nature of a sketch): the more delicate pencil sketch of varying density tends to improve the portrayal of the body volumes, the creases in the clothes, the intermediate tonal shifts, the grass in the meadow. Using washes (see page 5) seems useful and effective, especially when I draw this type of figure sketch, necessarily quick and synthetic, almost a visual and compositional 'memo'.

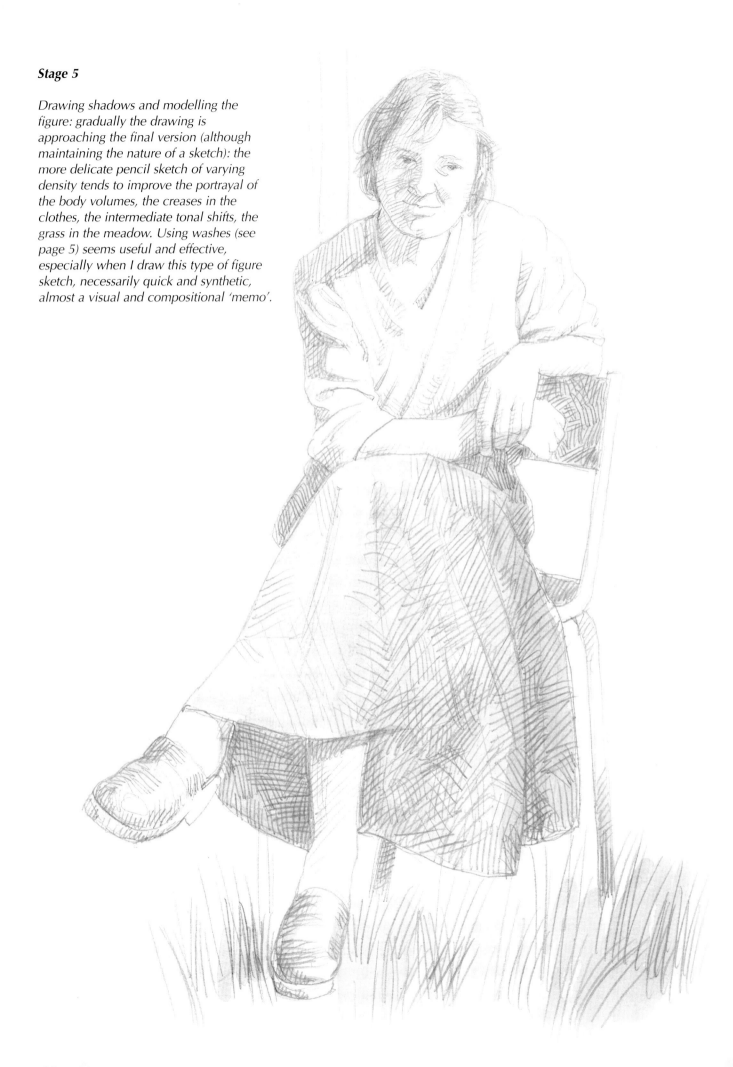

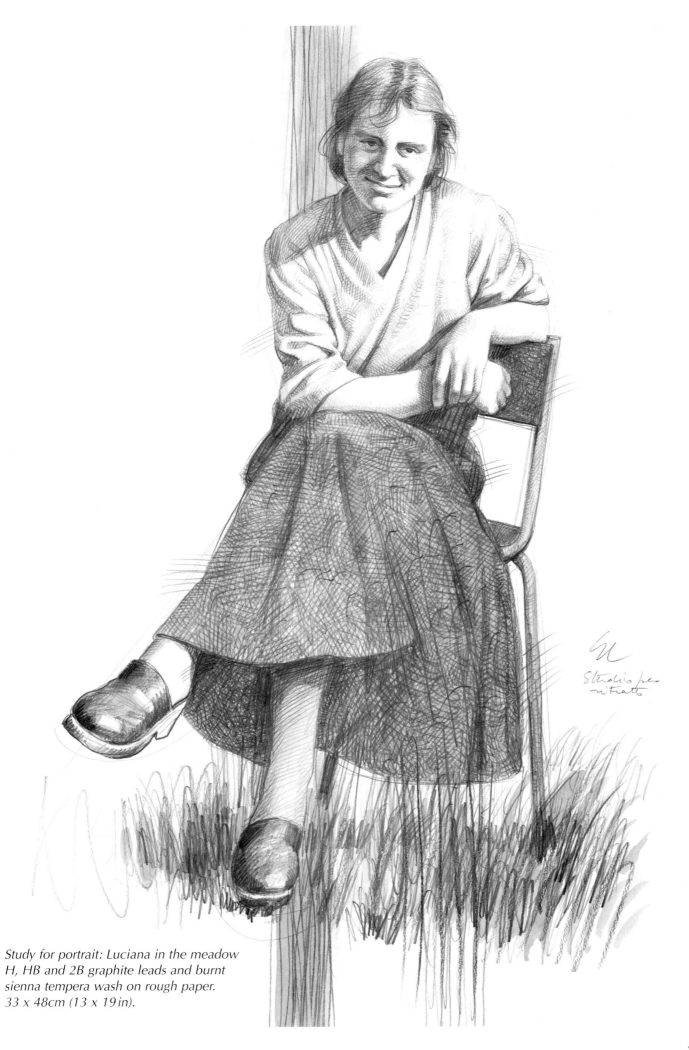

*Study for portrait: Luciana in the meadow
H, HB and 2B graphite leads and burnt
sienna tempera wash on rough paper.
33 x 48cm (13 x 19in).*

FIGURES IN EVERYDAY LIFE

In the town or country, wherever you live or happen to be staying, it won't be difficult for you to find people willing to pose for your drawings, if you have the wisdom not to abuse their availability. For example, you can portray relatives or friends while they are carrying out their domestic, work-related or recreational activities, or you can stop at places frequented by tourists, whose spontaneous and relaxed positions are sometimes maintained long enough to allow you to make a sufficiently elaborate study (see pages 23, 28, 33).

If you happen to portray children, you will find that the situation is often complicated by their restlessness: sometimes, with some cunning (for example, pretending they are taking part in a game), you can manage to keep them quiet for a while.

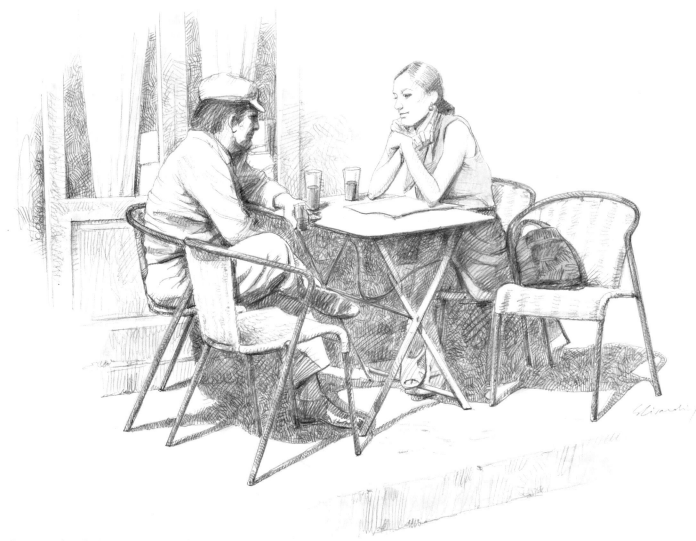

Conversation in Montmartre (Paris)
H, HB graphite leads and sepia tempera on rough paper, 33 x 48cm (13 x 19 in).

If people are engaged in conversation, sitting at tables outside a café in a tourist spot, they will usually stay there for quite a long time, so it is possible to portray them with some ease, if rapidly. In this case, the drawing has been made in two stages: in the first I sketched the figures; in the second (with more calm and certainty about them staying put) I drew the complex structure of the chairs and tables, objects always on view outside the café. The direct light of the sun produces intense, well-defined shadows, which suggest spatial depth; with the contrasts and balances of the tonal masses, they make the profiles of the figures stand out.

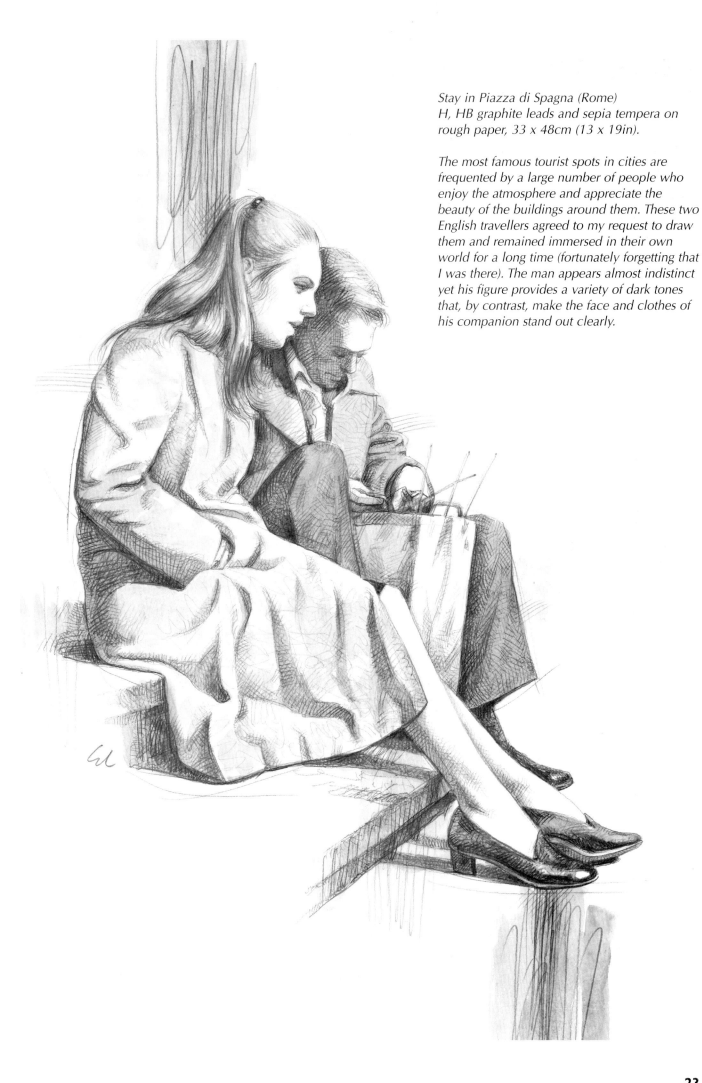

*Stay in Piazza di Spagna (Rome)
H, HB graphite leads and sepia tempera on
rough paper, 33 x 48cm (13 x 19in).*

*The most famous tourist spots in cities are
frequented by a large number of people who
enjoy the atmosphere and appreciate the
beauty of the buildings around them. These two
English travellers agreed to my request to draw
them and remained immersed in their own
world for a long time (fortunately forgetting that
I was there). The man appears almost indistinct
yet his figure provides a variety of dark tones
that, by contrast, make the face and clothes of
his companion stand out clearly.*

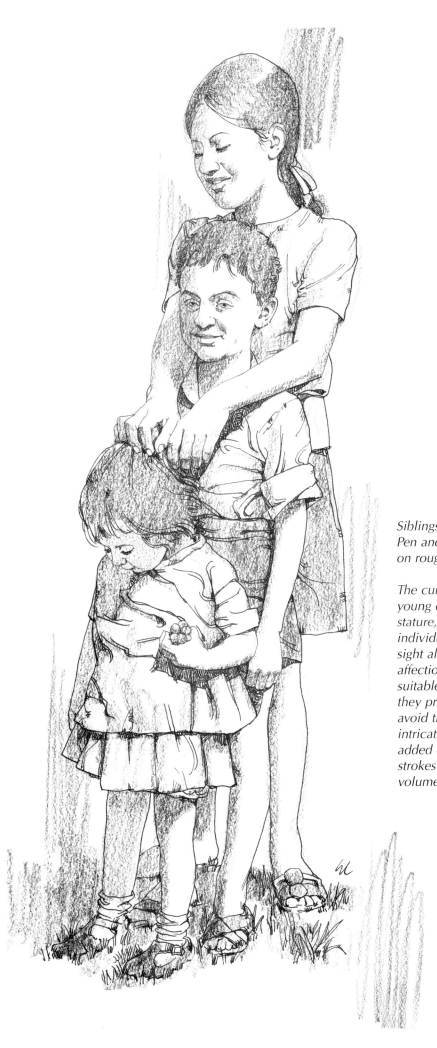

Siblings: scale
Pen and black China ink, 6B graphite lead
on rough paper, 33 x 48cm (13 x 19in).

The curious arrangement of these three
young children, descending in age and
stature, although well distinguished
individually, makes them appear at first
sight almost fused together in a delicate,
affectionate attitude. Pen and ink are
suitable in these circumstances because
they produce well-defined fine lines and
avoid the risk of confusion in very
intricate details. With some soft graphite I
added the few dark tonal background
strokes necessary to give at least a hint of
volumetric consistency to the forms.

Little family
Black watercolour on rough paper,
33 x 48cm (13 x 19in).

This drawing has all the
characteristics of a preparatory study
for a portrait (which was actually
produced, using oil on canvas). It
enabled me to assess and resolve
some problems with perspective
more easily than if I had relied on
observation, for example, the
apparent shortness of the mother's
legs or the chair's lack of depth.
These would have been unpleasant
if retained in the final work. Indeed
drawing from a model can also be
used precisely for this purpose: not
everything that seems to appear
volumetrically correct and natural in
real life then maintains its
effectiveness once transferred to the
flat surface of the sheet.

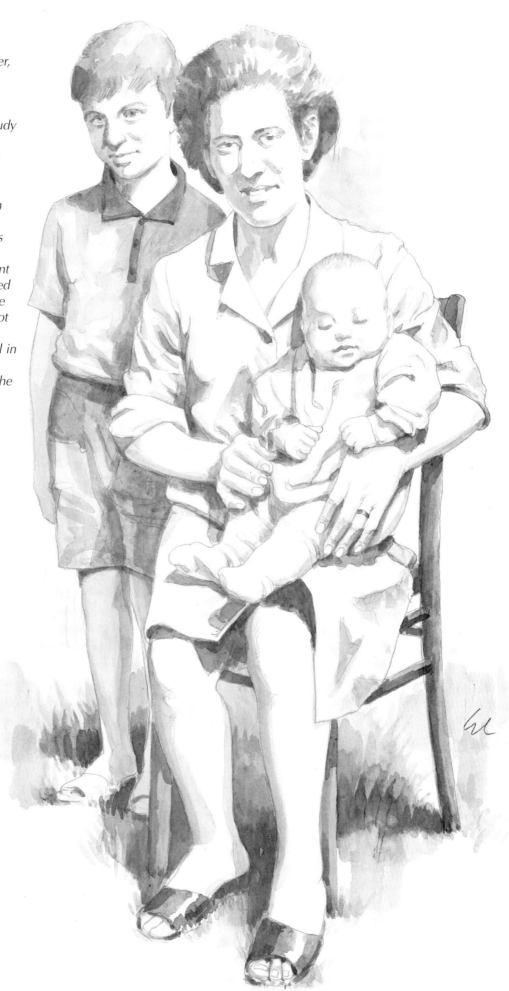

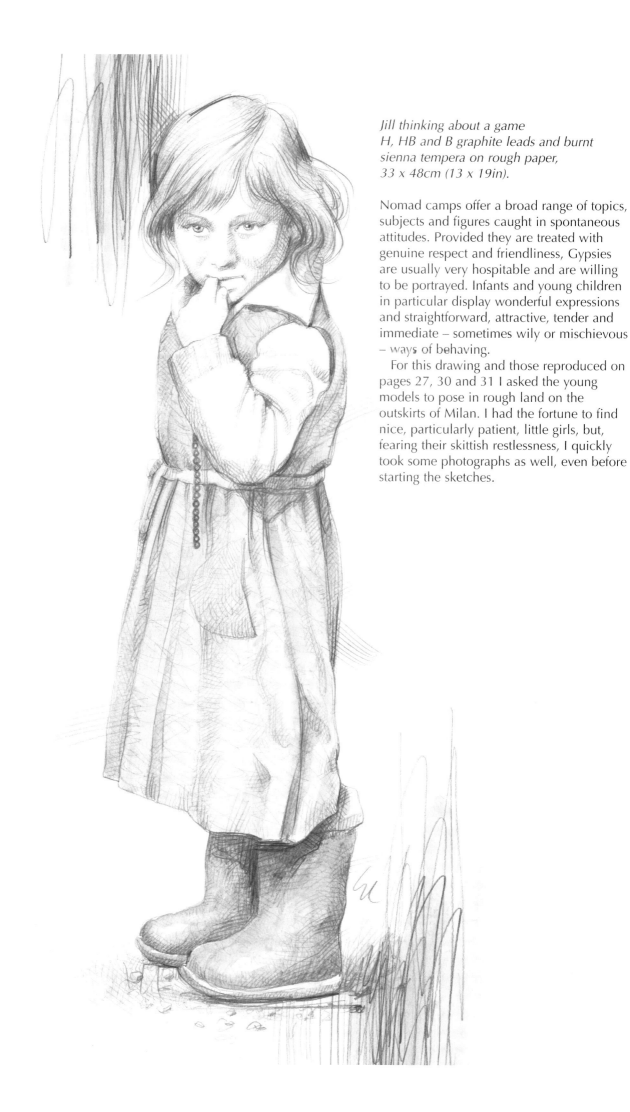

Jill thinking about a game
H, HB and B graphite leads and burnt
sienna tempera on rough paper,
33 x 48cm (13 x 19in).

Nomad camps offer a broad range of topics, subjects and figures caught in spontaneous attitudes. Provided they are treated with genuine respect and friendliness, Gypsies are usually very hospitable and are willing to be portrayed. Infants and young children in particular display wonderful expressions and straightforward, attractive, tender and immediate – sometimes wily or mischievous – ways of behaving.

For this drawing and those reproduced on pages 27, 30 and 31 I asked the young models to pose in rough land on the outskirts of Milan. I had the fortune to find nice, particularly patient, little girls, but, fearing their skittish restlessness, I quickly took some photographs as well, even before starting the sketches.

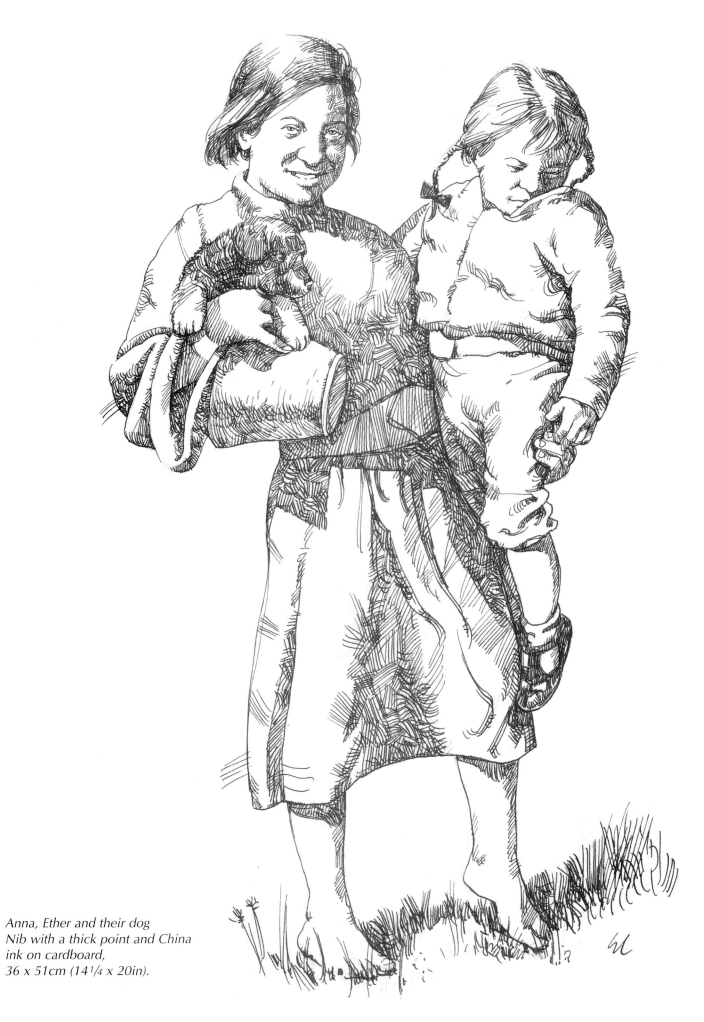

*Anna, Ether and their dog
Nib with a thick point and China
ink on cardboard,
36 x 51cm (14¹/4 x 20in).*

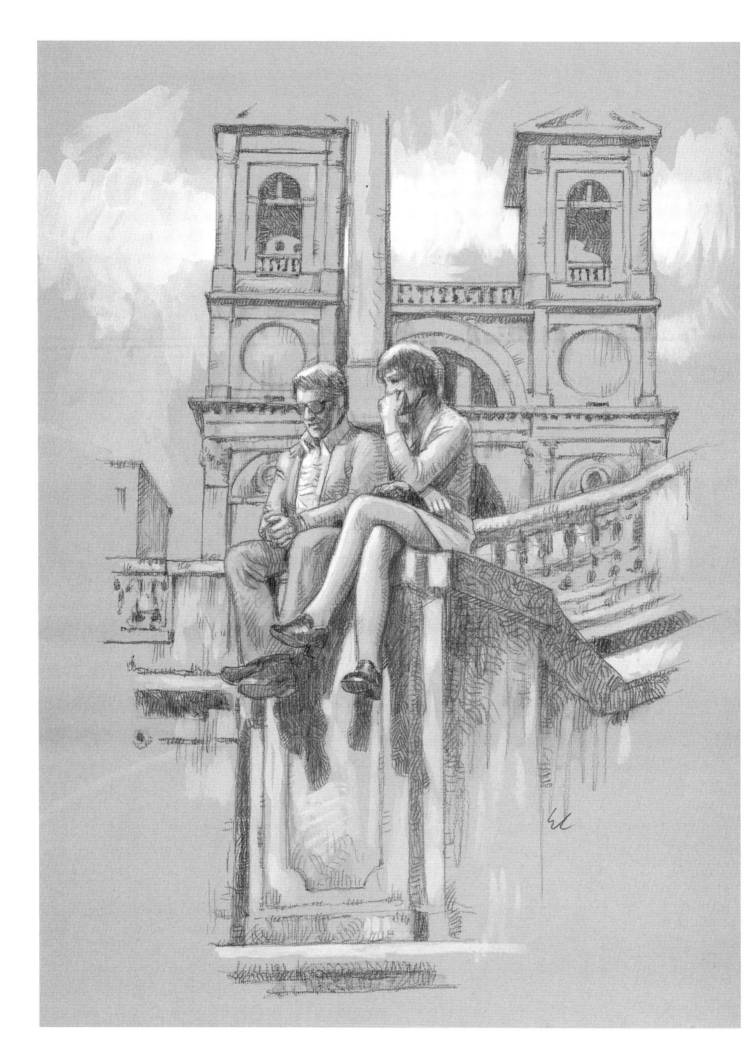

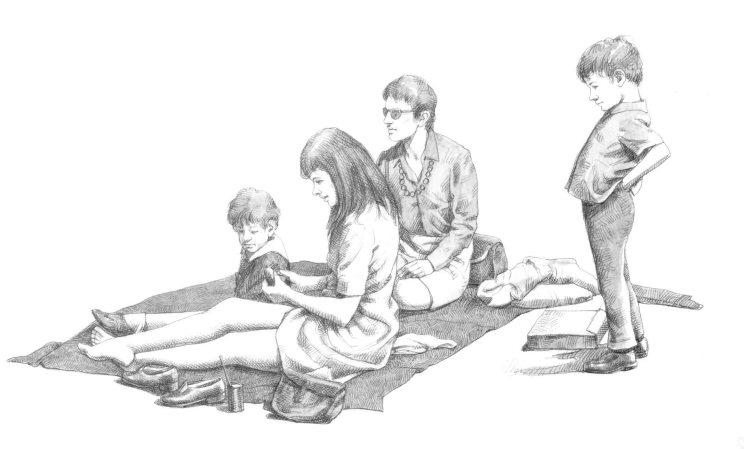

Picnic in Central Park (New York)
HB and B graphite leads and burnt sienna tempera on rough paper,
33 x 48cm (13 x 19in).

This small group of people was drawn only partly directly from life, on the shore
of a small lake in the park. The boy on the right, although part of the company,
was moving too quickly and often, so much so that it made it impossible to
sketch his boisterous gestures on the paper. So I photographed him in some
strange poses and, later, I completed the drawing inspired by an attitude that
seemed to fit in with the composition.

Page 28

Trinità dei Monti (Rome)
B graphite lead, white and burnt sienna tempera on sand-coloured paper,
32 x 45cm (12 1/2 x 17 3/4in).

When the background represents a predominant part of the drawing and is
very complicated it is advisable to draw it very briefly and instead devote all
the available time to the figures. At a later stage it will almost always be
possible to complete the background details by returning to the place or
referring to photographs.

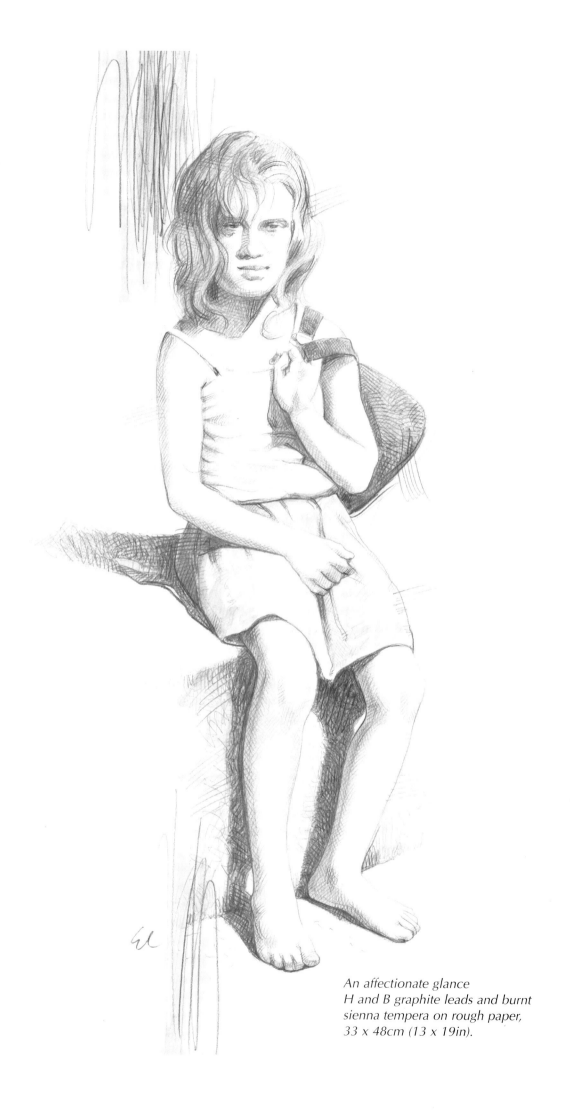

An affectionate glance
H and B graphite leads and burnt
sienna tempera on rough paper,
33 x 48cm (13 x 19in).

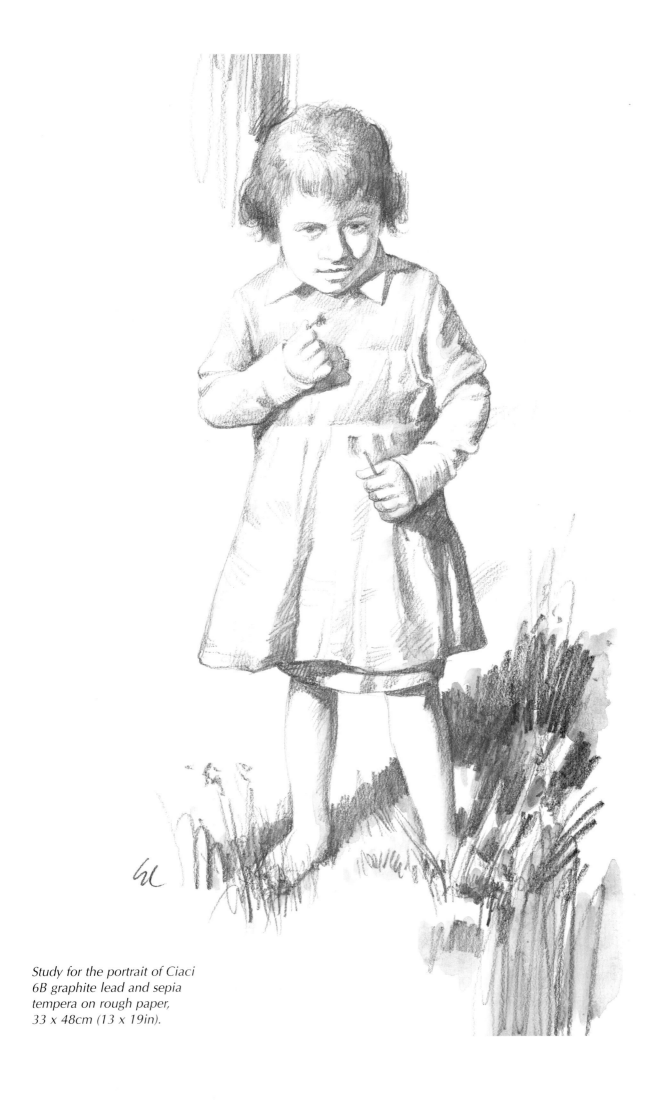

Study for the portrait of Ciaci
6B graphite lead and sepia
tempera on rough paper,
33 x 48cm (13 x 19in).

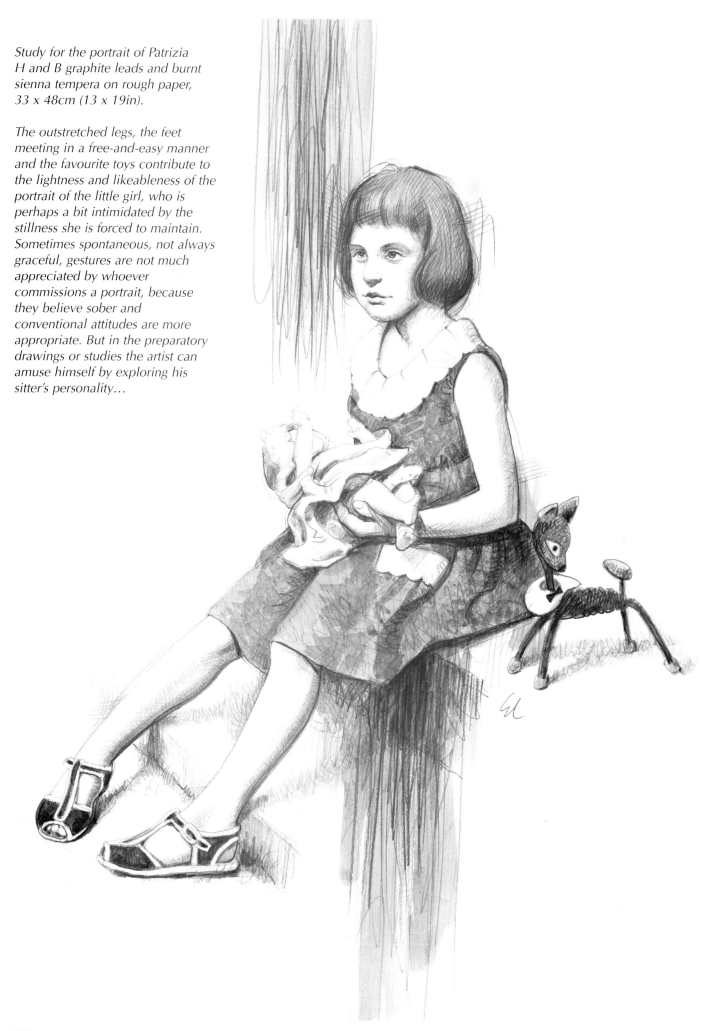

Study for the portrait of Patrizia H and B graphite leads and burnt sienna tempera on rough paper, 33 x 48cm (13 x 19in).

The outstretched legs, the feet meeting in a free-and-easy manner and the favourite toys contribute to the lightness and likeableness of the portrait of the little girl, who is perhaps a bit intimidated by the stillness she is forced to maintain. Sometimes spontaneous, not always graceful, gestures are not much appreciated by whoever commissions a portrait, because they believe sober and conventional attitudes are more appropriate. But in the preparatory drawings or studies the artist can amuse himself by exploring his sitter's personality…

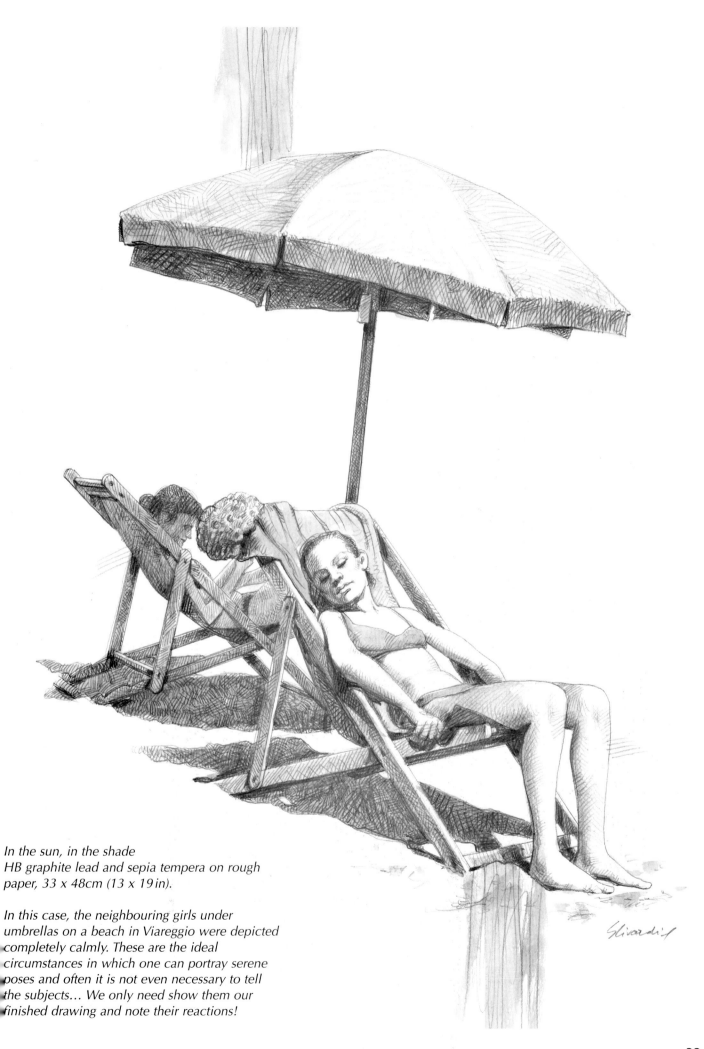

In the sun, in the shade
HB graphite lead and sepia tempera on rough
paper, 33 x 48cm (13 x 19 in).

In this case, the neighbouring girls under
umbrellas on a beach in Viareggio were depicted
completely calmly. These are the ideal
circumstances in which one can portray serene
poses and often it is not even necessary to tell
the subjects… We only need show them our
finished drawing and note their reactions!

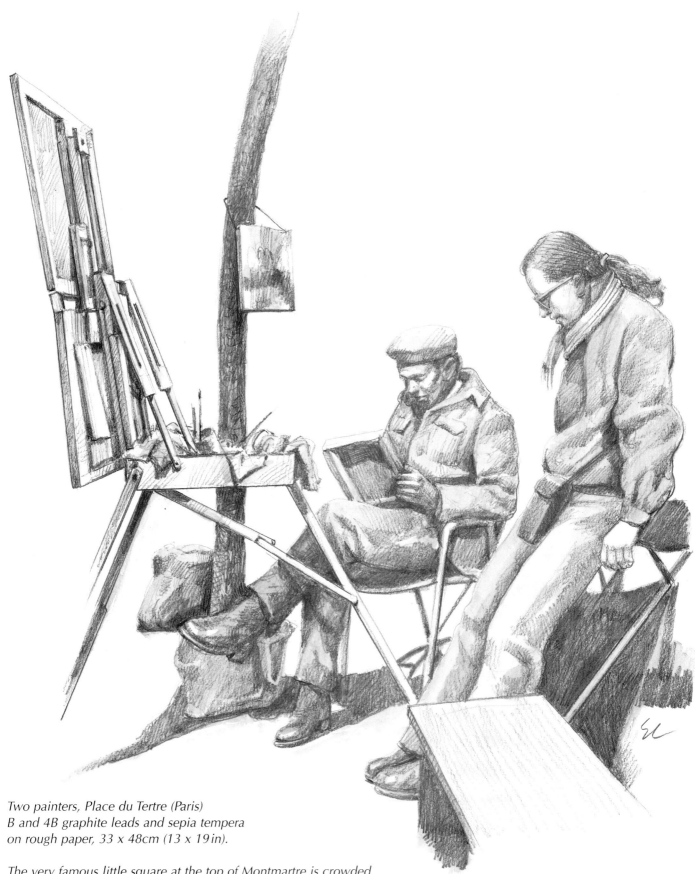

Two painters, Place du Tertre (Paris)
B and 4B graphite leads and sepia tempera
on rough paper, 33 x 48cm (13 x 19in).

The very famous little square at the top of Montmartre is crowded
throughout most of the year with slightly eccentric-looking painters as
well as tourists who wander about between trees, easels and chairs at
open-air restaurants. It is a strange experience, then, to portray other artists
who make their living from drawing portraits. Usually they are very willing (perhaps they're
not afraid of the competition) and, more often than not, their comments can be instructive.

 In this drawing I preferred to isolate some subjects of interest from the background, concen-
trating on the dovetailed shapes and elements that stand out, that are connected and superim-
posed on each other and thus draw the viewer's gaze to the central figure.

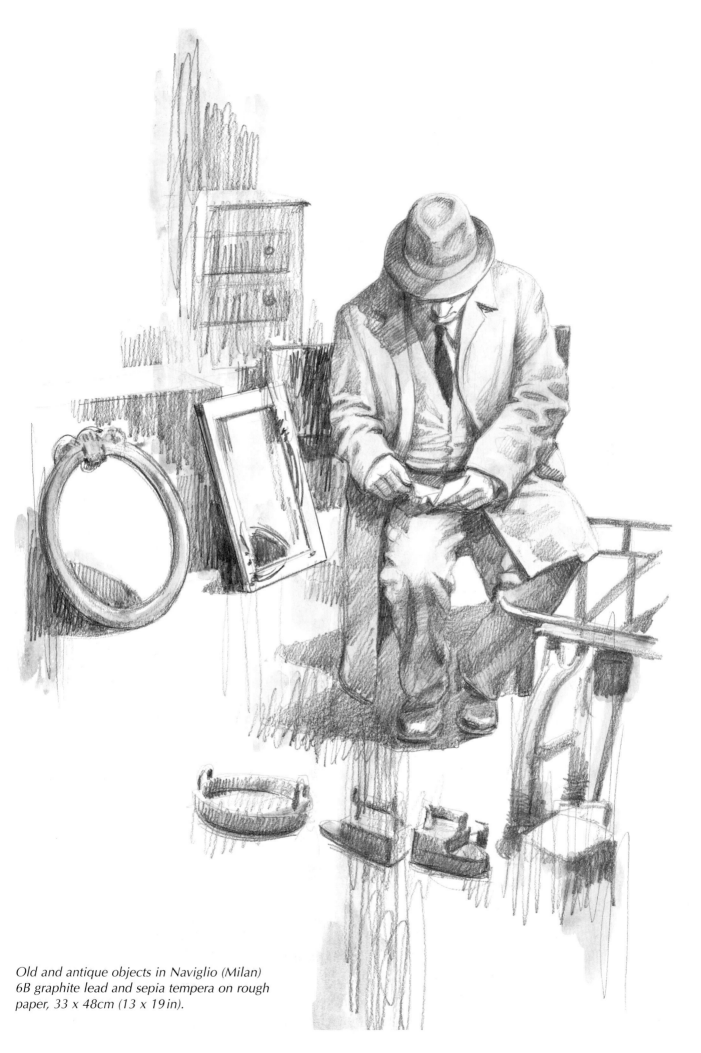

Old and antique objects in Naviglio (Milan)
6B graphite lead and sepia tempera on rough
paper, 33 x 48cm (13 x 19 in).

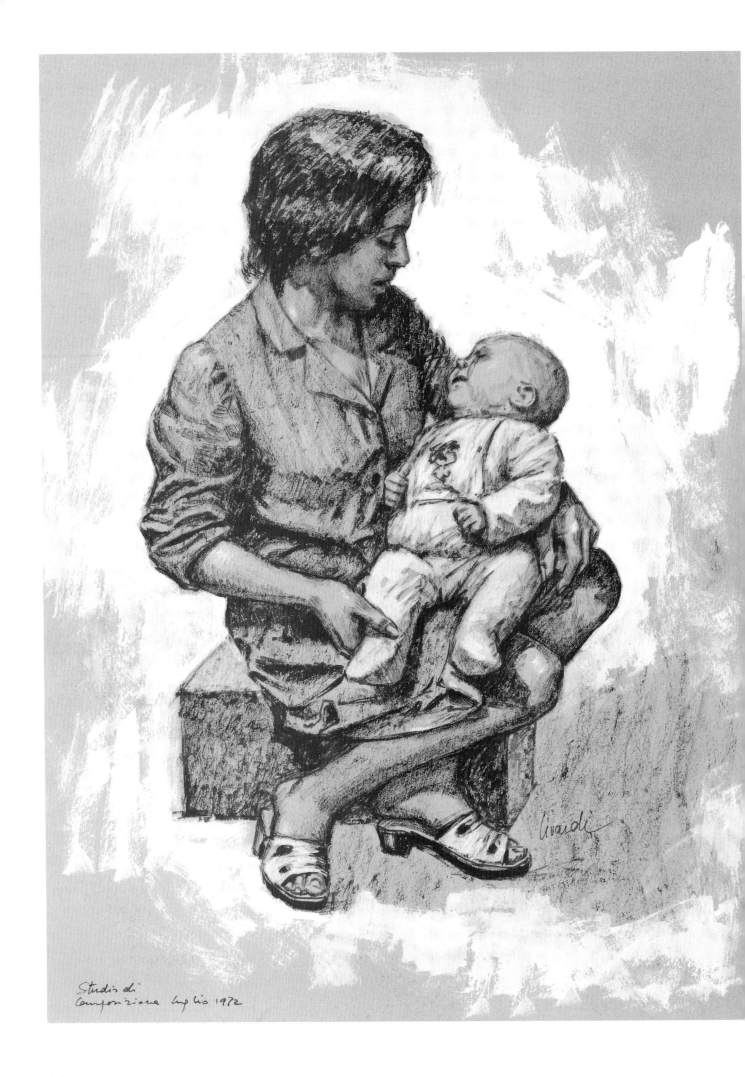

Studio di
Composizione Luglio 1972

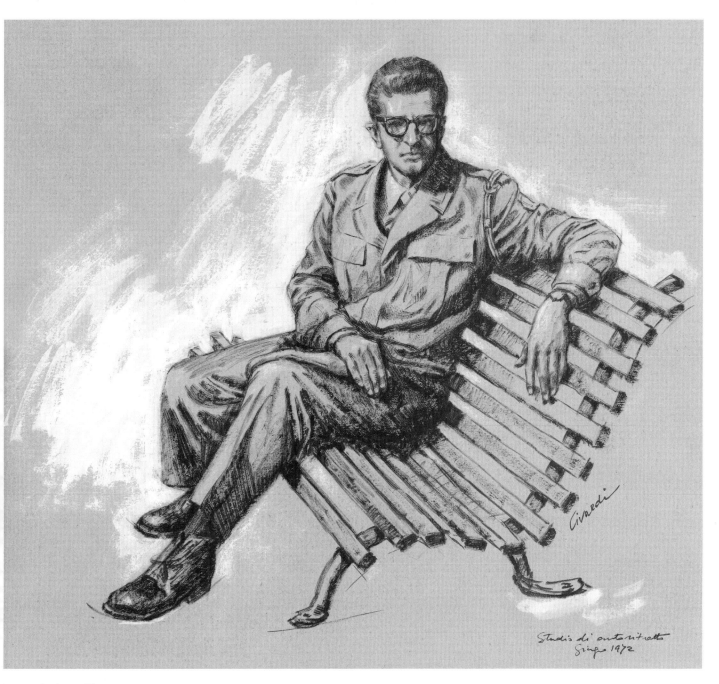

Study for self-portrait
Dry-brush, ink and white tempera on grey card, 32.5 x 36cm (12¾ x 14½in)
(from a photograph).

Page 36

Composition study
Dry-brush, ink and white tempera on grey card, 32 x 43cm (12½ x 17in).

The drawings reproduced on these two pages were made many years ago. In both I used the dry-brush technique to apply the broken, fringed, black China ink strokes. The technique is easy: dip a medium-sized soft-hair brush in the ink; dry it a bit on some cloth and then lightly apply the various strokes on a fairly rough sheet of paper. The effect is obtained quickly and is particularly effective for figure drawings where the parts in the shade form a definite contrast with those that are illuminated.

TRAVEL DIARY

When travelling, many artists are accustomed to taking with them (as well as their cameras) a sketch book for jotting down their visual experiences in the places they are visiting: foreshortenings of landscapes or architecture, people's attitudes, notes about colour or composition, etc. Anything that attracts our attention is portrayed with quick sketches and kept for possible future elaboration. On these pages I have reproduced some drawings that I did during a trip to Northern India; although they were produced in a short space of time, some of them, thanks to the patience of the 'models' (rewarded with a few rupees) or favourable circumstances, were comparatively thoroughly made. However, many others (and they are the majority of those I did) are mere graphic notes, drawn in a few moments (page 43) and therefore can be included in the category of sketches referred to on page 7.

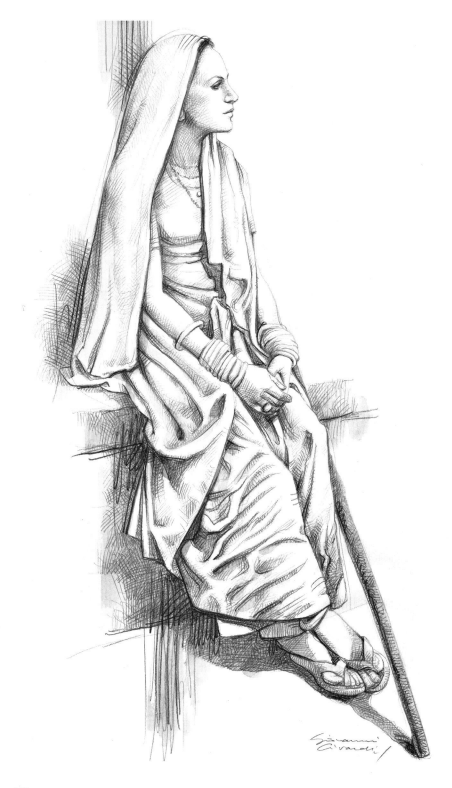

Lady at the market, in Jaisalmer
2B graphite lead and burnt sienna
tempera on rough paper,
33 x 48cm (13 x 19 in).

This drawing and those reproduced up to page 43 were made over several days in some markets in the Indian city of Jaisalmer and in fairly uncomfortable conditions – surrounded (not to say crushed) by a small, curious, loud crowd. But the discomfort was amply compensated for by the extreme willingness of the people who agreed – and were happy – to be portrayed (and certainly welcomed some rupees…).

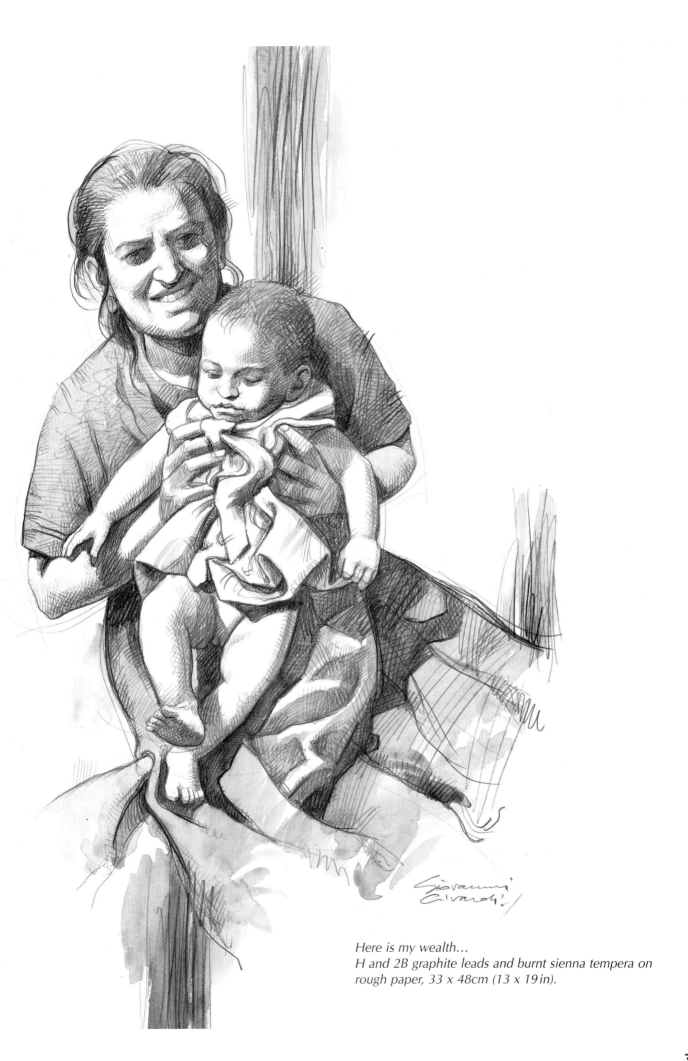

Here is my wealth…
H and 2B graphite leads and burnt sienna tempera on
rough paper, 33 x 48cm (13 x 19 in).

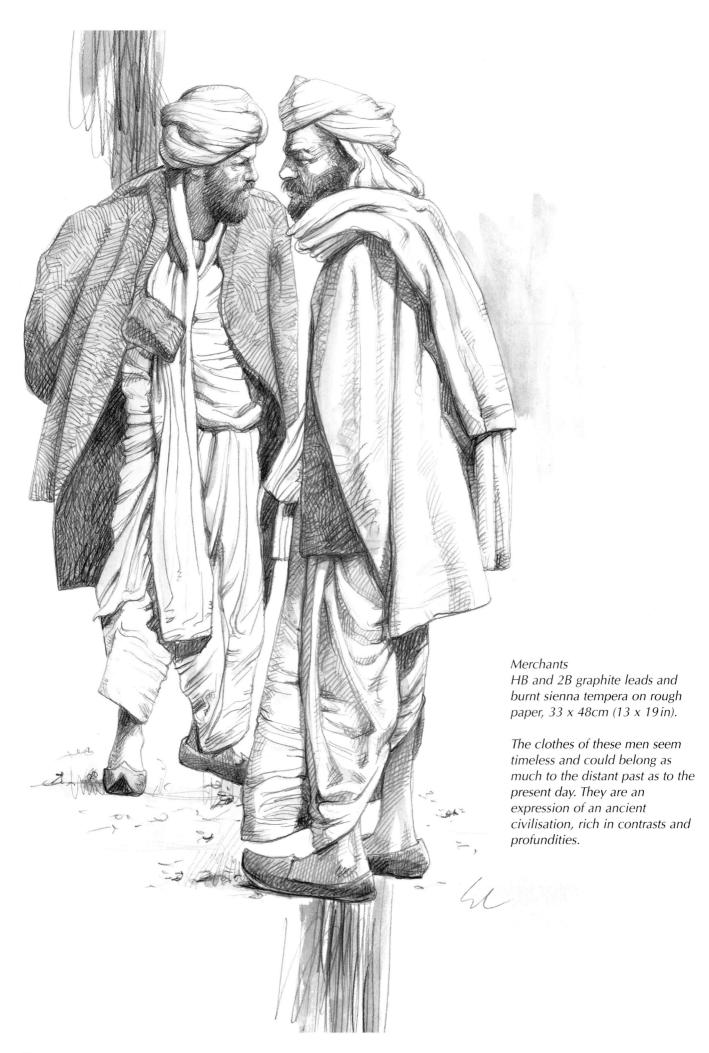

Merchants
HB and 2B graphite leads and burnt sienna tempera on rough paper, 33 x 48cm (13 x 19 in).

The clothes of these men seem timeless and could belong as much to the distant past as to the present day. They are an expression of an ancient civilisation, rich in contrasts and profundities.

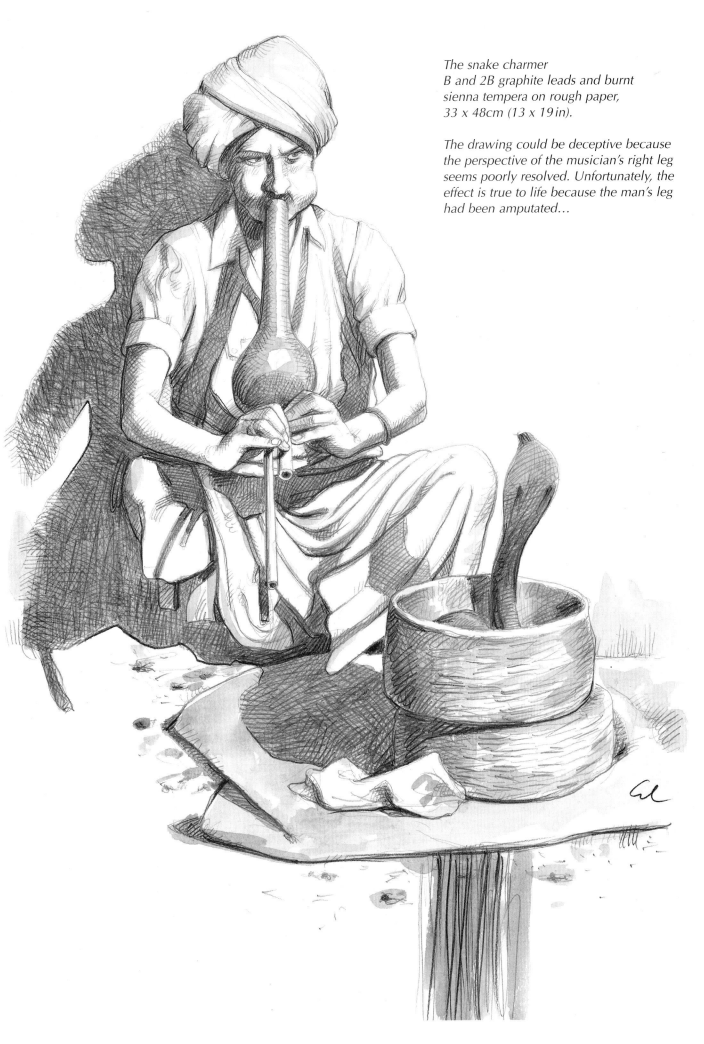

The snake charmer
B and 2B graphite leads and burnt
sienna tempera on rough paper,
33 x 48cm (13 x 19in).

The drawing could be deceptive because
the perspective of the musician's right leg
seems poorly resolved. Unfortunately, the
effect is true to life because the man's leg
had been amputated…

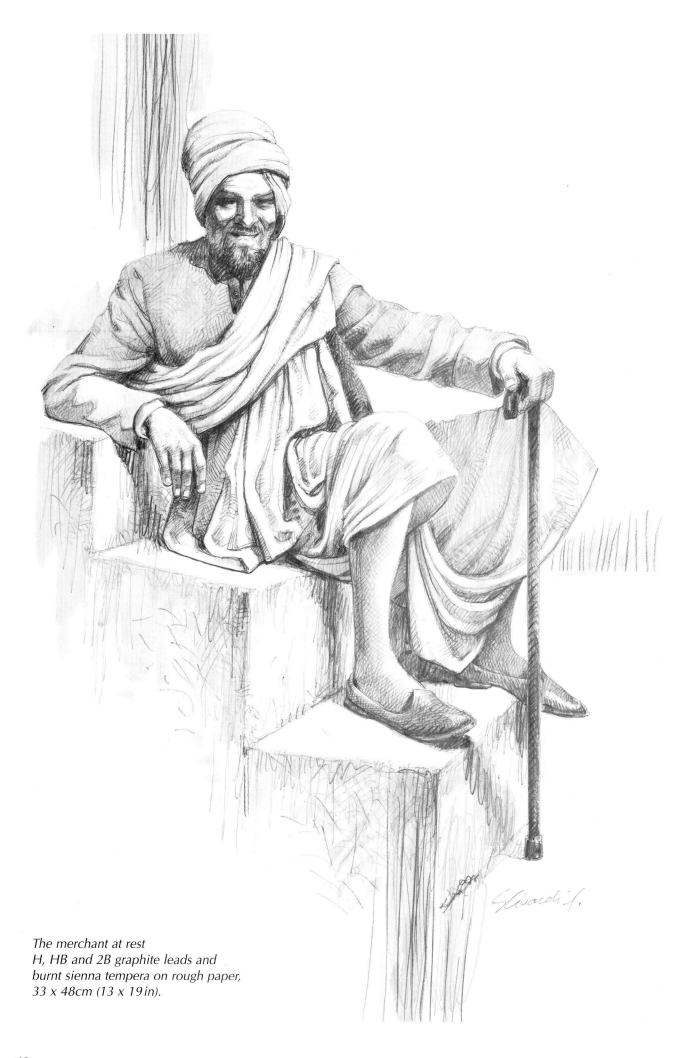

The merchant at rest
H, HB and 2B graphite leads and
burnt sienna tempera on rough paper,
33 x 48cm (13 x 19in).

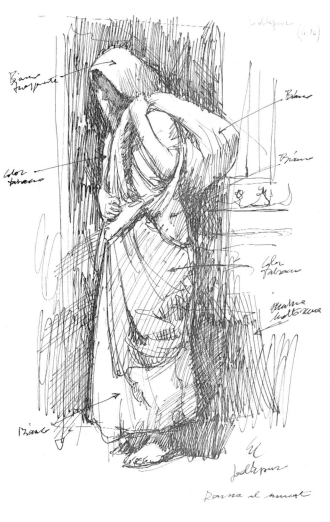

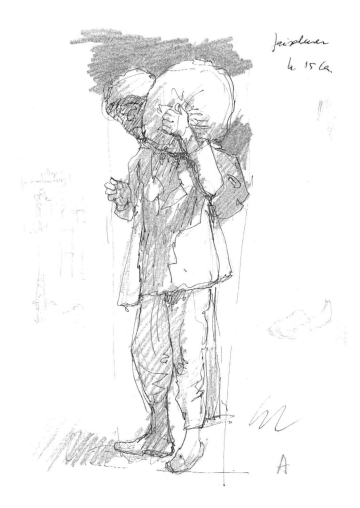

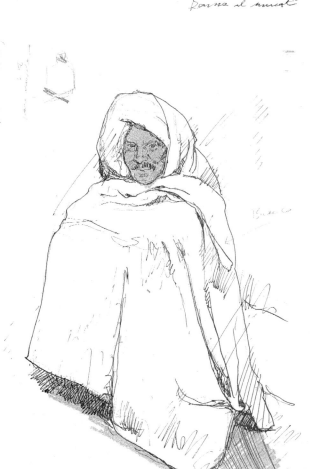

Pages from the travel diary
Pen and black China ink, 2B graphite lead each drawing 20 x 30cm (7¾ x 11¾in).

Unlike the drawings shown on the previous pages (and in nearly the whole book), these are typical examples of sketches done very quickly – simple visual notes (similar, in some respects, to 'snapshots') which capture only the tension of the movement or the overall appearance of the gesture and attitude (see page 7).

OLD-FASHIONED COSTUMES

The clothes in fashion in the past, let's say until the beginning of the 20th century, offer many interesting opportunities for any artist who loves to portray the figures wearing them. For example, there is a wide variety of styles, colours, accessories and decorative elements, and a broad range of creases in the ample, abundant fabrics. These stand out through the intense contrasting and intersecting of parts in light and shade. I did some of these drawings inspired by photographs taken during the medieval and Renaissance costume parades held in Asti each year, during the Palio. In fact, except for the drawings shown on pages 47, 49 and 51 (for which the paraders posed for some time on the day of the trials before the Palio), the sketches depict attitudes that are too fleeting or complex to be able to capture them fully. In these cases, it is very useful to combine a rapid sketch from life with some supporting, reference photographs.

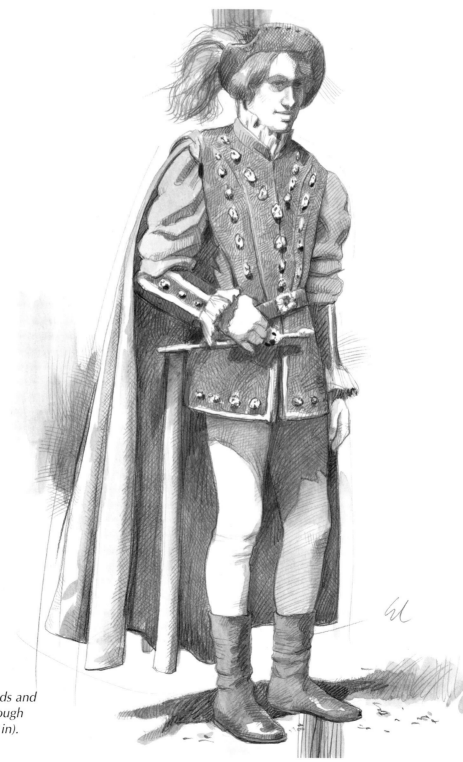

*Parader in old-fashioned
costume
H, HB and 2B graphite leads and
burnt sienna tempera on rough
paper, 33 x 48cm (13 x 19 in).*

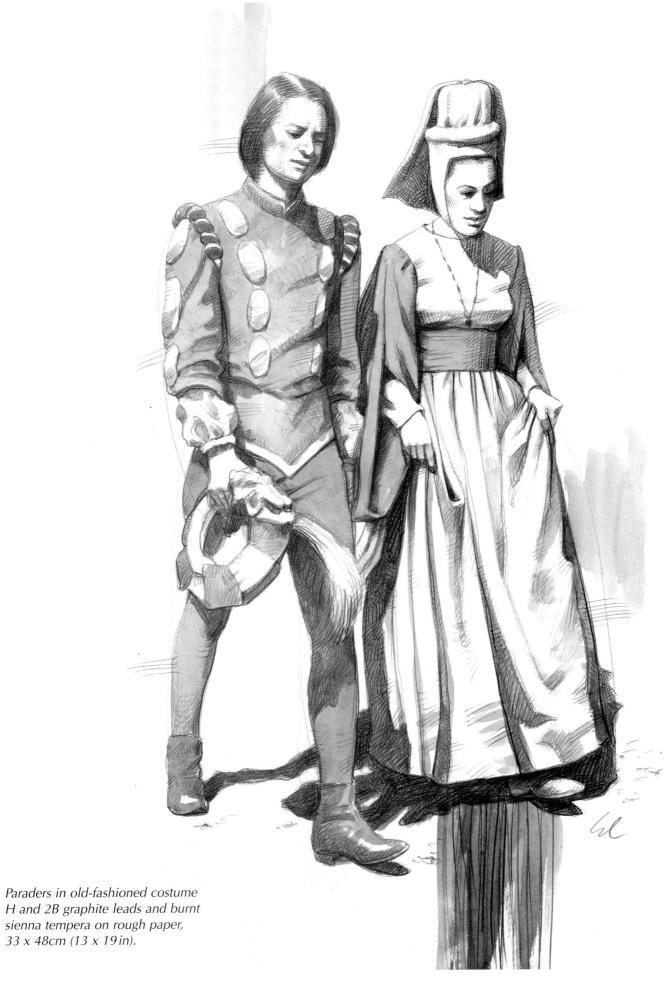

Paraders in old-fashioned costume
H and 2B graphite leads and burnt
sienna tempera on rough paper,
33 x 48cm (13 x 19 in).

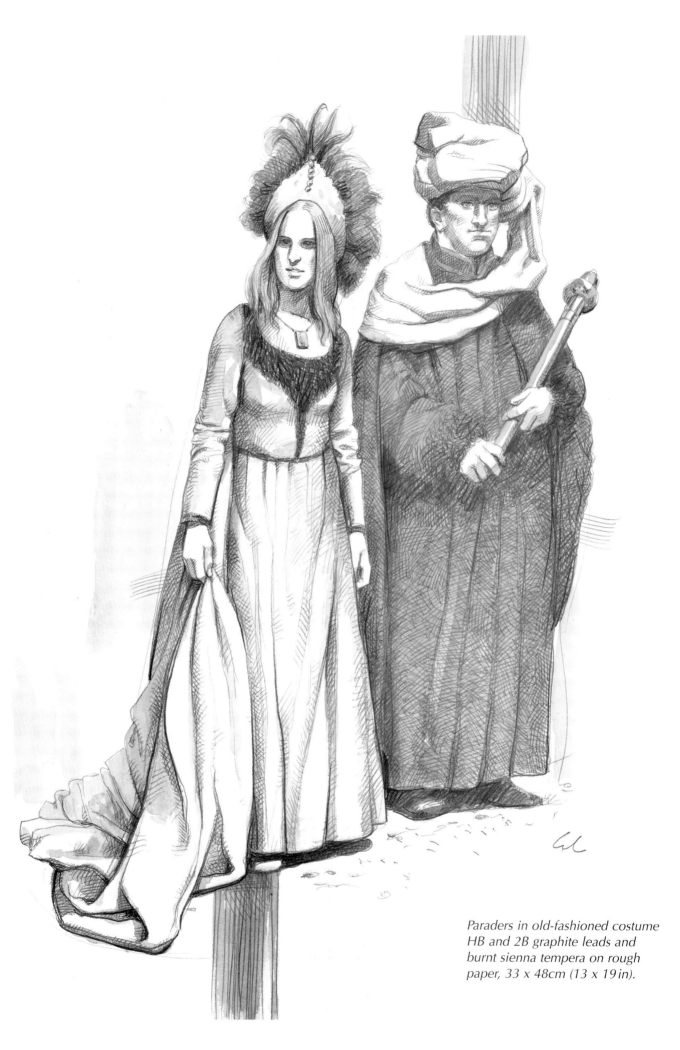

Paraders in old-fashioned costume HB and 2B graphite leads and burnt sienna tempera on rough paper, 33 x 48cm (13 x 19in).

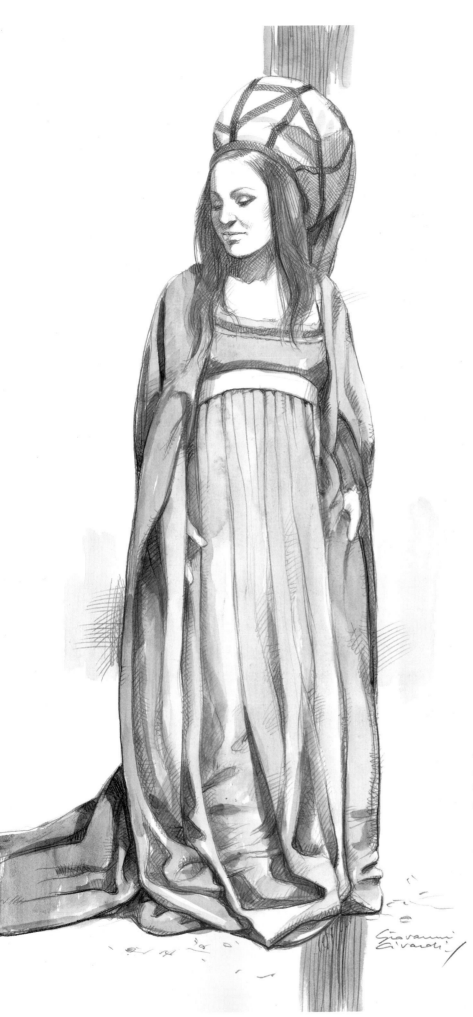

*Parader in old-fashioned costume
HB and 2B graphite leads and
burnt sienna tempera on rough
paper, 33 x 48cm (13 x 19 in).*

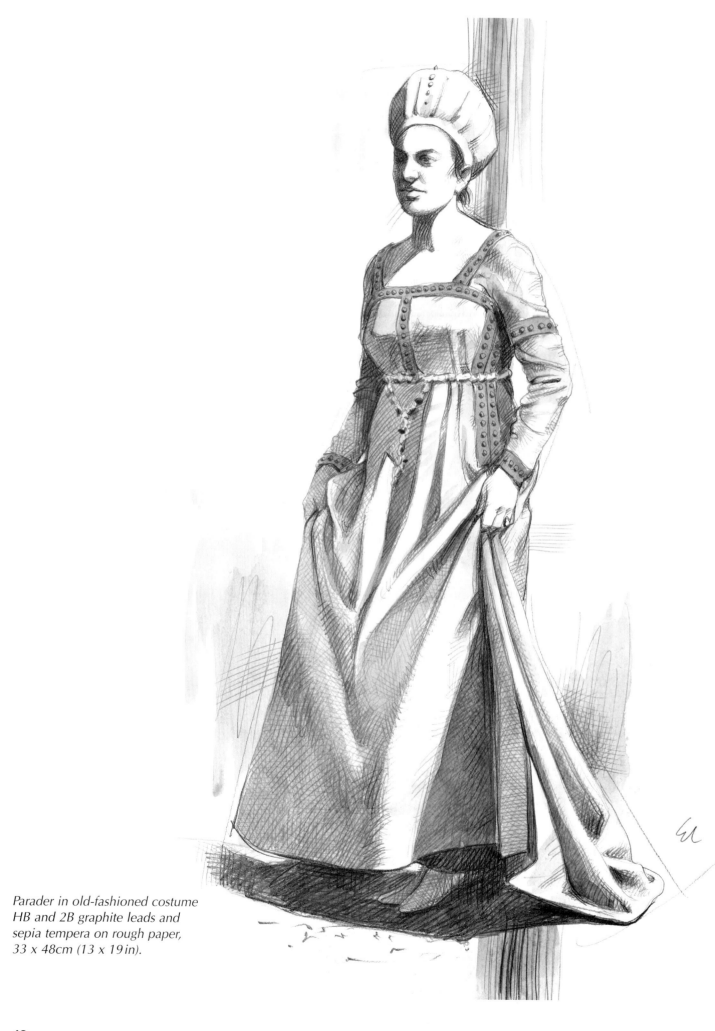

Parader in old-fashioned costume
HB and 2B graphite leads and
sepia tempera on rough paper,
33 x 48cm (13 x 19 in).

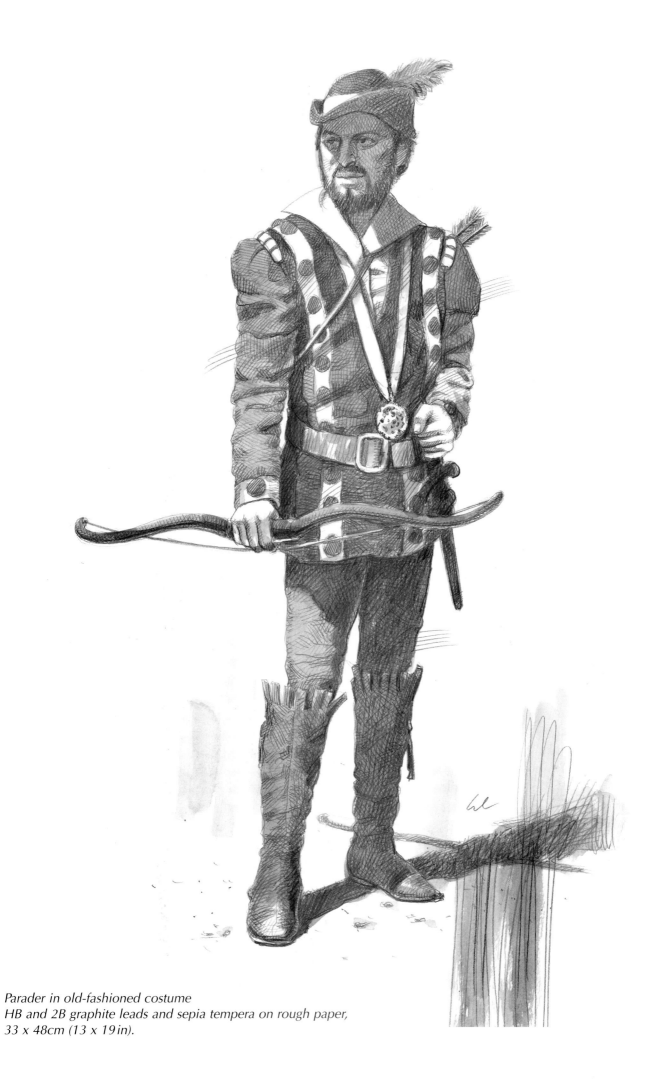

Parader in old-fashioned costume
HB and 2B graphite leads and sepia tempera on rough paper,
33 x 48cm (13 x 19 in).

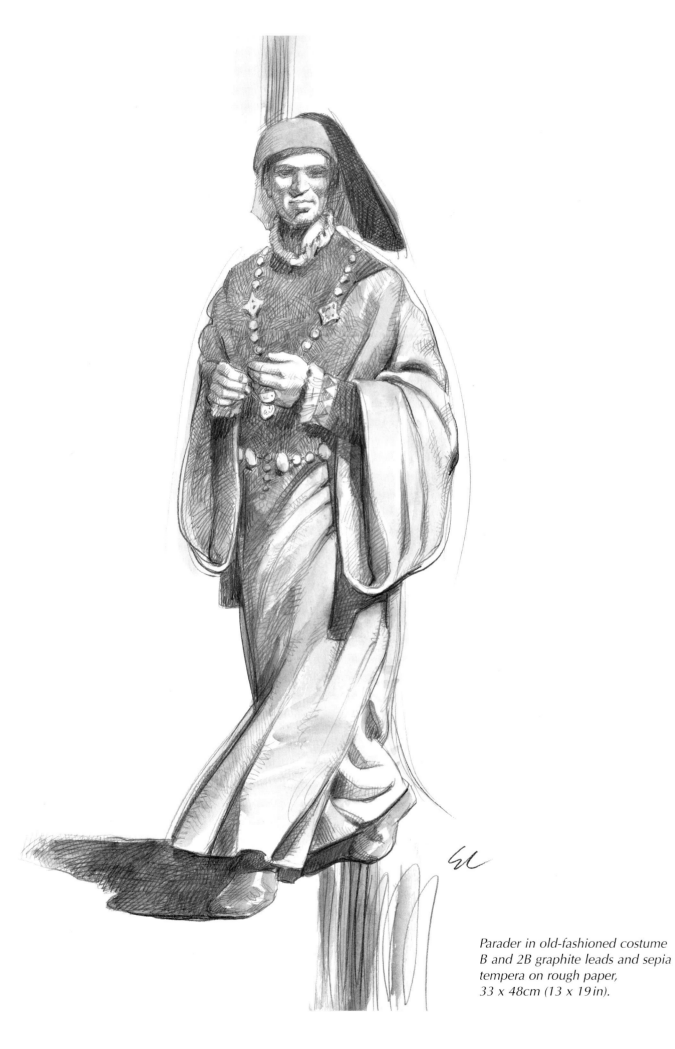

Parader in old-fashioned costume
B and 2B graphite leads and sepia
tempera on rough paper,
33 x 48cm (13 x 19in).

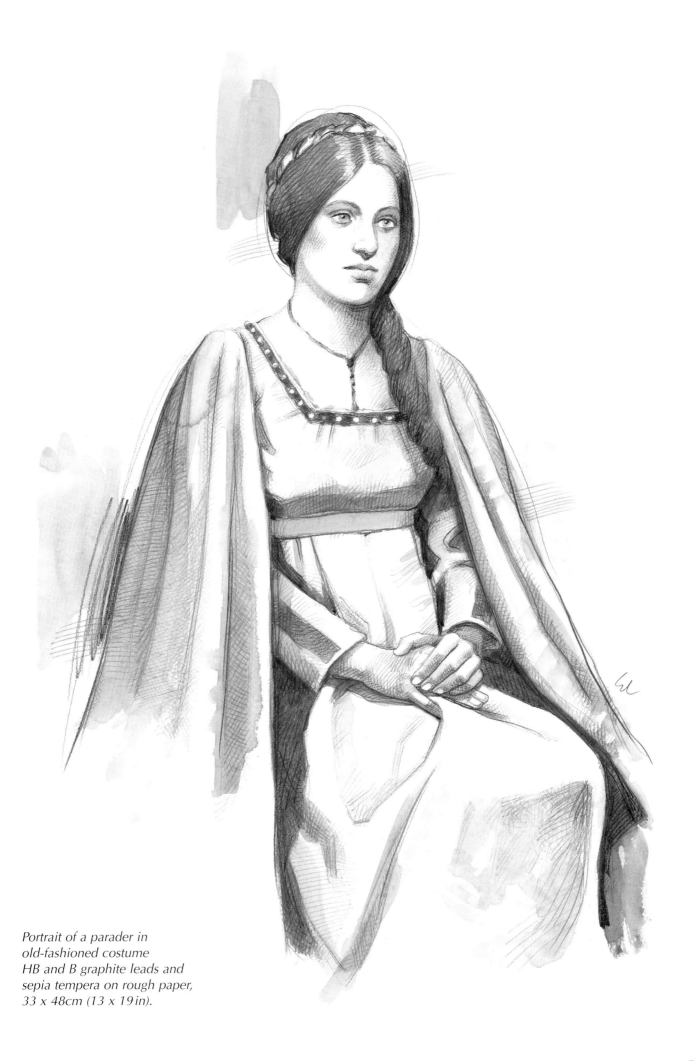

Portrait of a parader in
old-fashioned costume
HB and B graphite leads and
sepia tempera on rough paper,
33 x 48cm (13 x 19 in).

GROUPS OF FIGURES

Parks, public gardens, squares in art cities, markets or shopping centres, playing fields, restaurants… These are the sort of places whose people meet or arrive in groups, and provide useful opportunities for artists. They should use this opportunity to practise portraying people doing something together or simply when they are near each other in a relaxed and casual way. They are composition exercises which means that by taking advantage of the spontaneous and casual appearance of a group it is possible (just by doing a simple sketch) to select the most meaningful aspects of the surroundings and characters. In fact, if after some time you examine your drawings not from a purely aesthetic point of view (it is obvious that they are rough, incomplete sketches), but with regard to how the figures have been arranged on the sheet, you will discover some very curious and educational things about the intuitive way in which you managed to arrange the 'background portrait'.

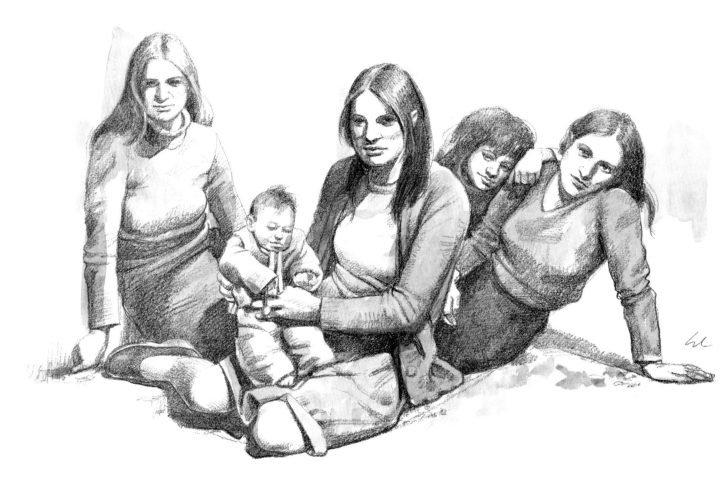

Gypsy family
2B and 6B graphite leads and sepia tempera on rough paper, 33 x 48cm (13 x 19in).

This group of sisters was captured in a serene, relaxed attitude so I was able to draw them with some degree of calm. The figures are not arranged symmetrically, but the casual, spontaneous composition has a certain dynamic balance, rich in tensions and contrasts (the verticality of the arms, the inclination of the heads, etc.). The creases in the clothes suggest and complete the foreshortening effects and help give the individual figures a volumetric appearance.

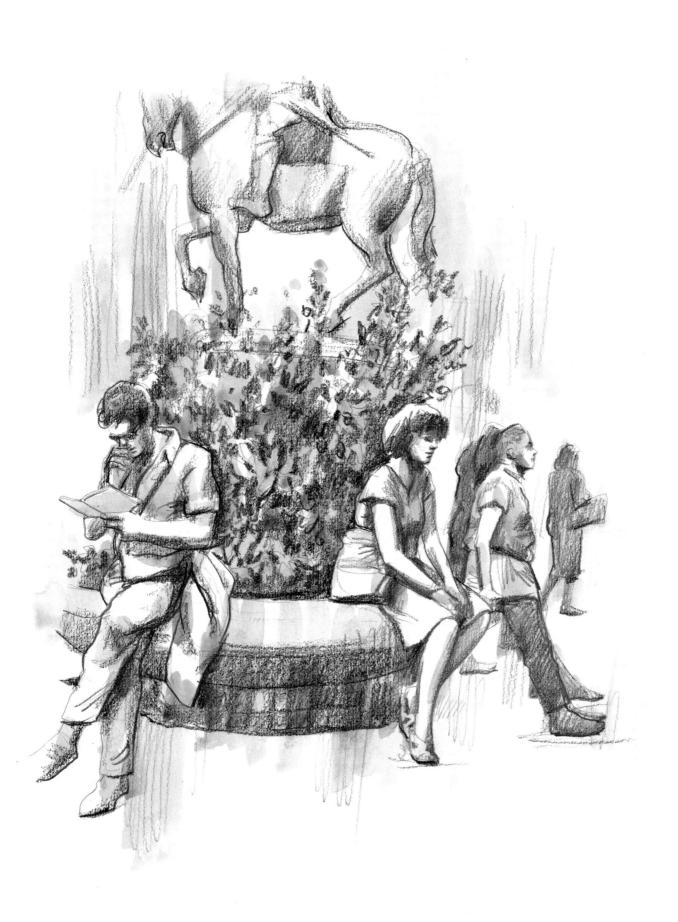

Tourists in Piazza della Signoria (Florence)
6B graphite lead and sepia tempera on rough paper, 33 x 48cm (13 x 19 in).

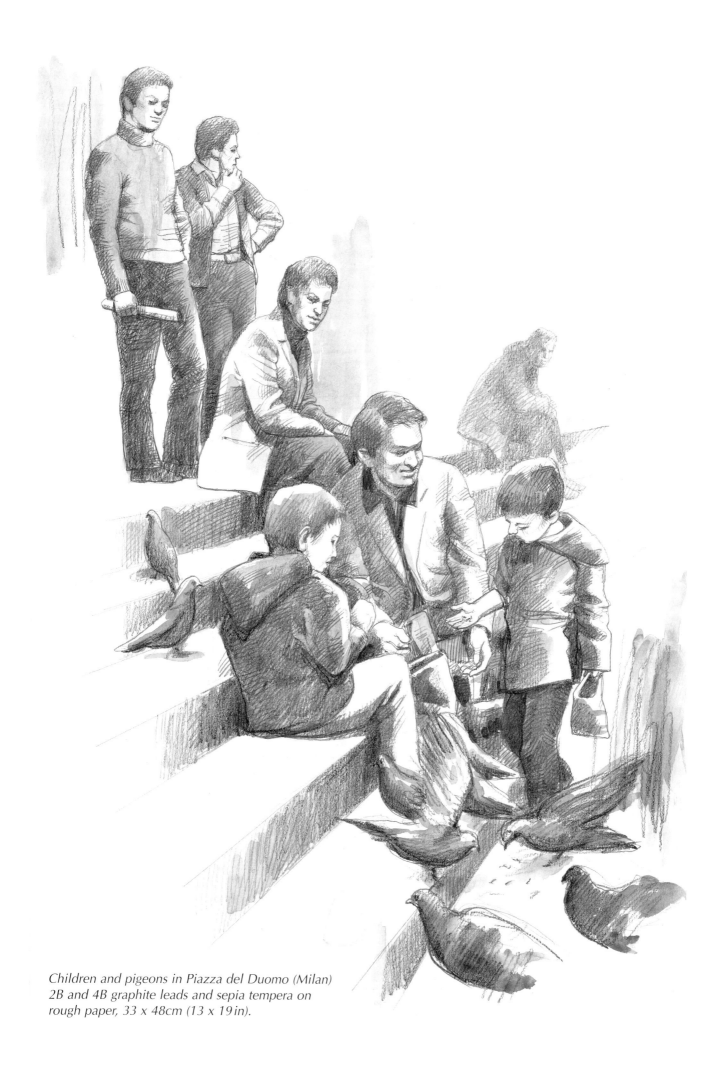

Children and pigeons in Piazza del Duomo (Milan)
2B and 4B graphite leads and sepia tempera on
rough paper, 33 x 48cm (13 x 19 in).

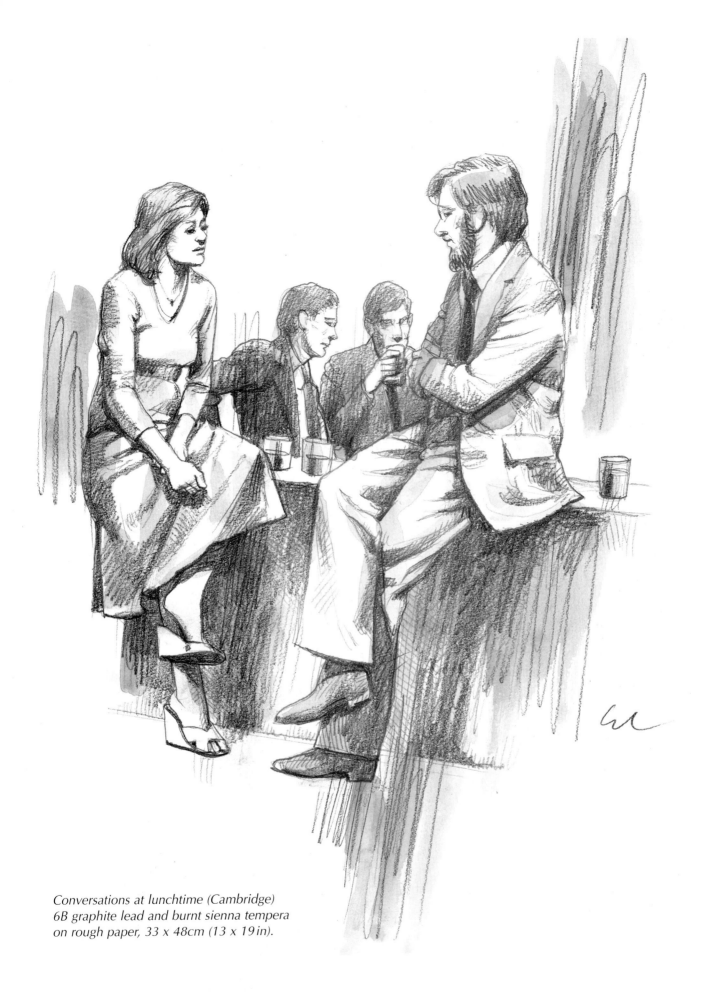

Conversations at lunchtime (Cambridge)
6B graphite lead and burnt sienna tempera
on rough paper, 33 x 48cm (13 x 19 in).

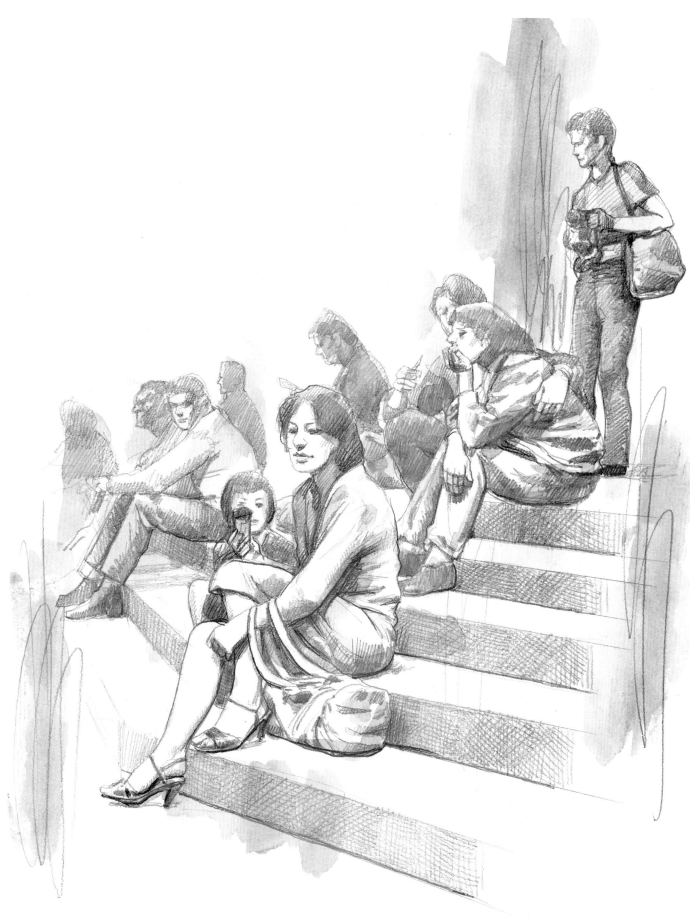

In front of Palazzo Vecchio (Florence)
H and 2B graphite leads and sepia tempera on rough
paper, 33 x 48cm (13 x 19 in).

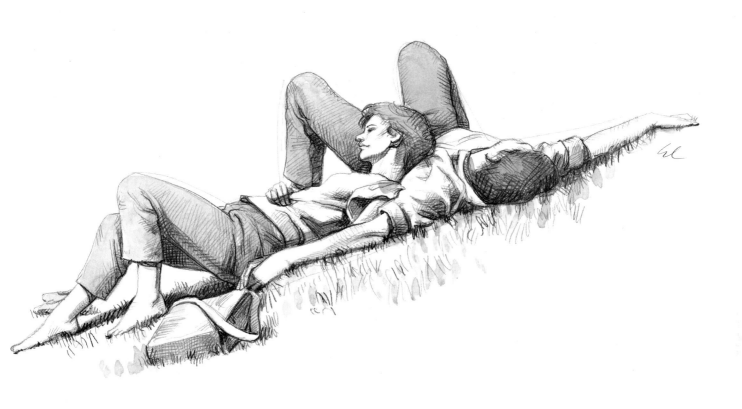

First sun
2B and 4B graphite leads and sepia tempera on rough paper, 24 x 33 cm (9 1/2 x 13in).

The diagonal arrangement of these two figures who are resting quietly and in an attitude of delicate affection in a meadow in Villa Borghese, Rome, immediately interested me. Maybe because during the many years I worked as an illustrator of romantic novels, I became more sensitive to this type of situation.

 The clothing is represented in a very synthetic way: we only need introduce a few creases at the crucial, important points (knees, shoulders, etc.) to suggest the state of the materials and the underlying anatomical structure.

CHOICE OF VIEWPOINT AND ATTITUDE

It is not true to say that a figure whose attitude attracted your attention must be reproduced exactly from the visual angle from which you discerned it. If it is a position that the subject promises to hold for long enough (and even before you inform them of your artistic intentions), try to walk round the model or, at least, move a few steps away, so as to see them from a different viewpoint, for example, their profile as well as from the front. Or wait until the model shifts a bit, poses slightly differently, perhaps in a more interesting and meaningful way. There is also the risk that the model will go way, but don't worry too much: you will have lost the chance of a drawing from life, and yet the attention paid to the situation and your visual memory will leave just as useful an impression in your experience. The spontaneity of the gesture, if associated with a good compositional effect, can produce a drawing or sketch perhaps worthy of being transferred to a more complex and demanding work.

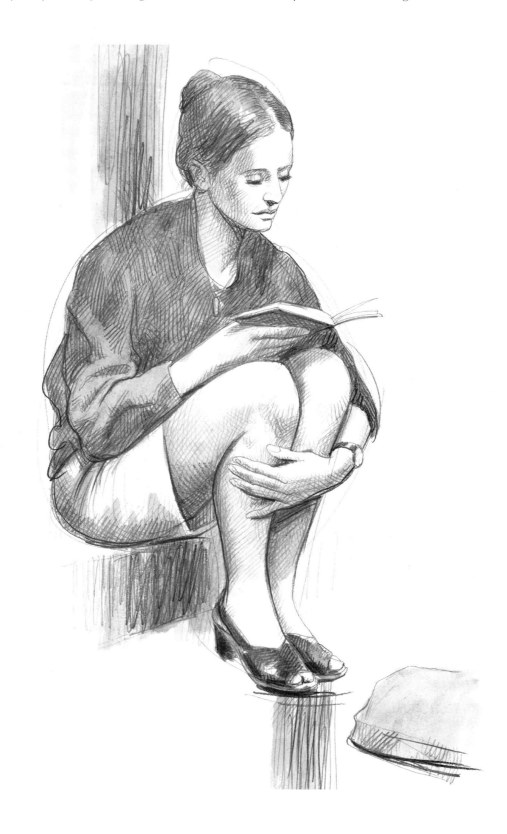

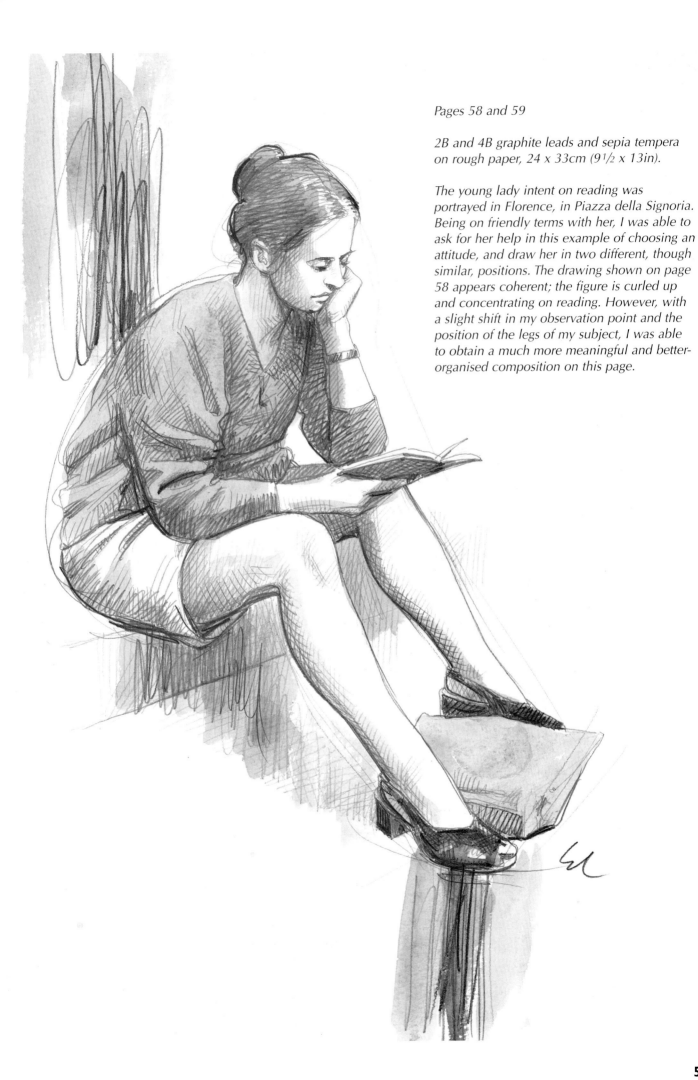

Pages 58 and 59

2B and 4B graphite leads and sepia tempera on rough paper, 24 x 33cm (9¹/₂ x 13in).

The young lady intent on reading was portrayed in Florence, in Piazza della Signoria. Being on friendly terms with her, I was able to ask for her help in this example of choosing an attitude, and draw her in two different, though similar, positions. The drawing shown on page 58 appears coherent; the figure is curled up and concentrating on reading. However, with a slight shift in my observation point and the position of the legs of my subject, I was able to obtain a much more meaningful and better-organised composition on this page.

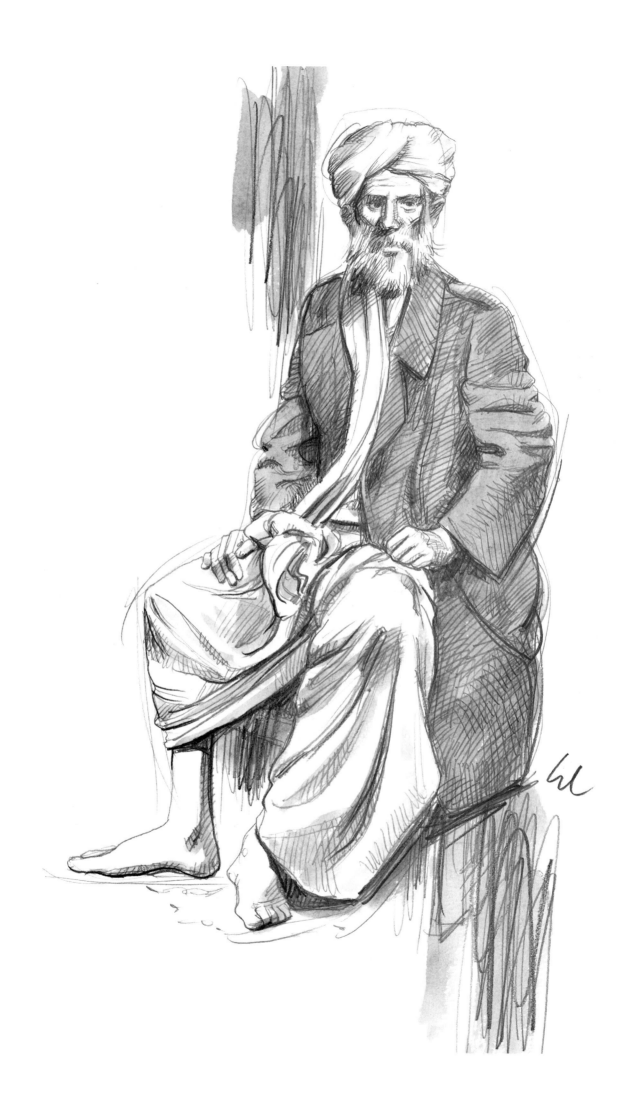

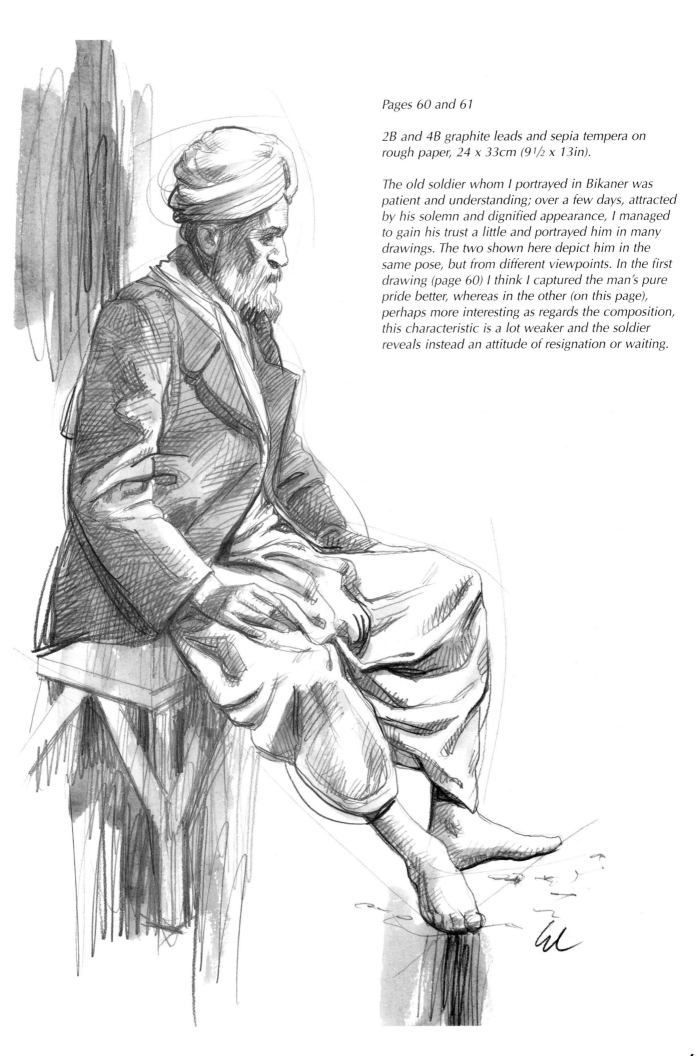

Pages 60 and 61

2B and 4B graphite leads and sepia tempera on rough paper, 24 x 33cm (9 1/2 x 13in).

The old soldier whom I portrayed in Bikaner was patient and understanding; over a few days, attracted by his solemn and dignified appearance, I managed to gain his trust a little and portrayed him in many drawings. The two shown here depict him in the same pose, but from different viewpoints. In the first drawing (page 60) I think I captured the man's pure pride better, whereas in the other (on this page), perhaps more interesting as regards the composition, this characteristic is a lot weaker and the soldier reveals instead an attitude of resignation or waiting.

B and 2B graphite leads and sepia tempera on rough paper, 24 x 33cm (9 1/2 x 13in).

For these illustrative drawings I used some photographs because the subject (an unknown tourist, in Florence) was in a precarious position and probably would have gone away after a few minutes. The two poses are almost identical and perhaps deciding which of these is the most attractive depends on subtle preferences based on sensitivity and personal taste. They both show interesting aspects: in the first sketch (on this page) the view from just below and from the side suggests the precariousness of the position well, whereas in the other (page 63) the figure appears more static. However, the composition seems to give this drawing the edge and the attitude appears more meaningful.

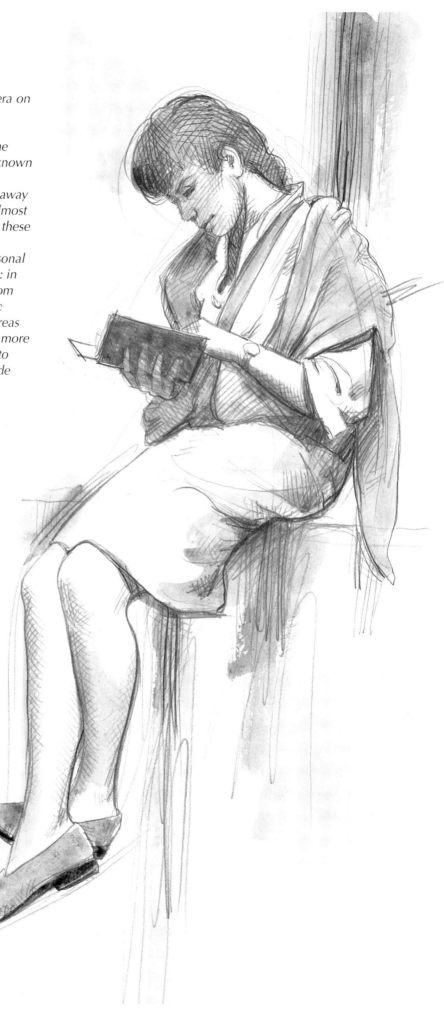

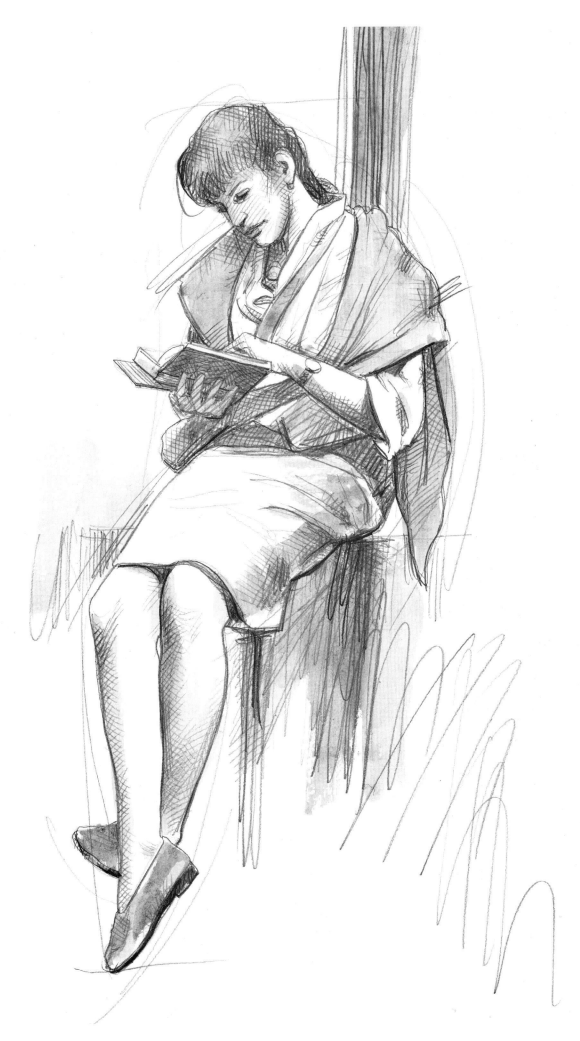

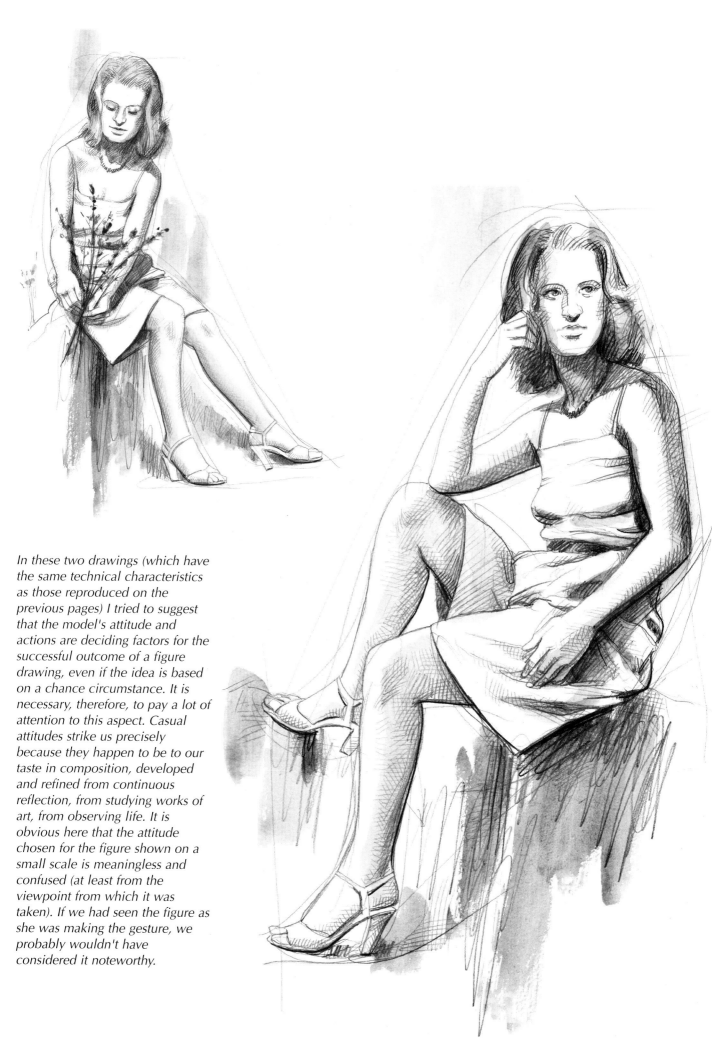

In these two drawings (which have the same technical characteristics as those reproduced on the previous pages) I tried to suggest that the model's attitude and actions are deciding factors for the successful outcome of a figure drawing, even if the idea is based on a chance circumstance. It is necessary, therefore, to pay a lot of attention to this aspect. Casual attitudes strike us precisely because they happen to be to our taste in composition, developed and refined from continuous reflection, from studying works of art, from observing life. It is obvious here that the attitude chosen for the figure shown on a small scale is meaningless and confused (at least from the viewpoint from which it was taken). If we had seen the figure as she was making the gesture, we probably wouldn't have considered it noteworthy.